frontispiece: *The Diary of a Seducer.* 1945. Oil, 50 x 62".
Mr. and Mrs. William A. M. Burden, New York

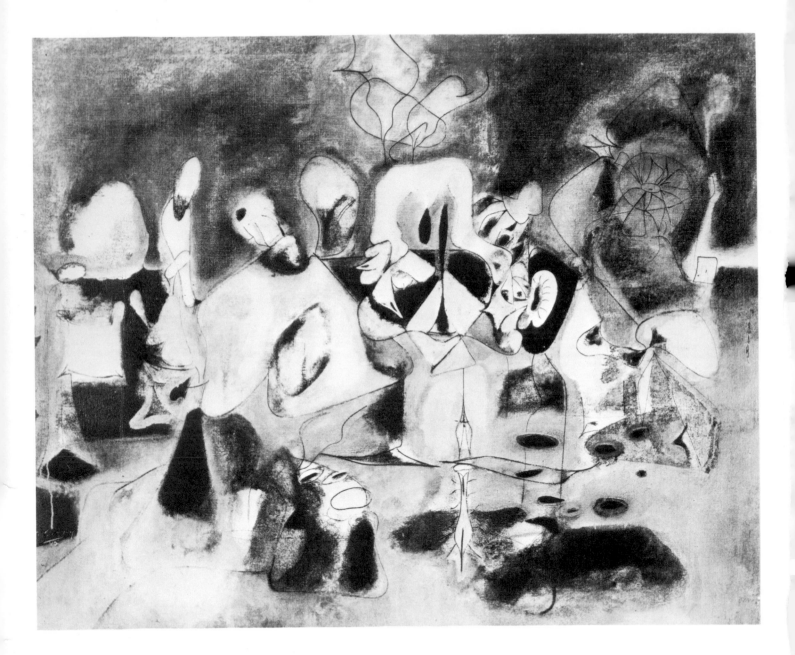

Arshile Gorky

Paintings Drawings Studies

BY WILLIAM C. SEITZ

WITH A FOREWORD BY JULIEN LEVY

THE MUSEUM OF MODERN ART, NEW YORK

IN COLLABORATION WITH

THE WASHINGTON GALLERY OF MODERN ART

Reprint Edition 1972 *Published for The Museum of Modern Art by Arno Press*

© 1962, The Museum of Modern Art
11 West 53 Street, New York 19, N. Y.

Library of Congress Catalog Card Number 75-169313
ISBN 0-405-01571-2

Printed in the U.S.A. by Pictorial Offset Corporation
Designed by Susan Draper

Contents

EXHIBITIONS:

The Museum of Modern Art, New York:
December 17, 1962
The Washington Gallery of Modern Art:
March 12, 1962

Acknowledgments

Several of Gorky's friends, and members of his family, gave assistance in preparing this exhibition. Mrs. Agnes Gorky Phillips was helpful not only by putting the paintings and drawings in the Gorky Estate at our disposal, but also in locating other works. Sidney Janis also helped in this regard. Ethel Schwabacher, whose sensitive and serious monograph I repeatedly consulted, answered dozens of additional questions and was kind enough to read and criticize this manuscript. Willam Agee acted as research assistant. Gorky's sister Mrs. Moorad Mooradian and his nephew Karlin Mooradian filled important gaps in my knowledge of Gorky's life. The staff of the Whitney Museum of American Art not only assisted us in preparing the exhibition, but opened their archives to us.

For his moving tribute to Gorky which serves as a foreword to the book, I wish to thank his friend and dealer Julien Levy, who also assisted me in documentation as did Jeanne Reynal, Will Barnet, Ara Ignatius, Frederick Kiesler, Abram Lerner, and several lenders to the exhibition; also Andrew C. Ritchie for his cooperation. In addition to the paragraphs quoted from Harold Rosenberg's book I was also assisted by his insights into certain aspects of Gorky's personality and art.

My short account of Gorky's development was edited by Helen Franc; Susan Draper designed the book and cover; Alicia Legg assembled the catalogue. For special assistance I wish to thank Mr. and Mrs. Frederick R. Weisman. On behalf of the Trustees of The Museum and The Washington Gallery of Modern Art I wish to thank all those who lent drawings and paintings.

Foreword

From poverty, or of a piece with his camouflage, for he was a very camouflaged man, Arshile Gorky as long as I knew him wore a patched coat, either an old tweed jacket with leather elbow pads in summer or in winter a ragged overcoat much too long for even his tall and lean frame. Inside his overcoat he would draw himself up, or lower himself without bending, so when he crouched, perhaps to examine a canvas, his coat crumpled down like an accordion as he folded his legs beneath it with the same muscles used by Caucasian dancers—although Gorky was not Caucasian, was in fact Armenian, and Gorky was not his real name. This is how camouflaged he was. His dark fierce face and ferocious black moustache concealed something soft and vulnerable and not easily approached even by his intimates. Strangers he either frightened or awed. Policemen, he told me proudly, often stopped him for questioning, "just because I look so dangerous," he said, but more probably because he was walking through traffic too absent-mindedly. Once in a dramatically illuminated exhibition in a museum he appeared suddenly conspicuous beneath one of the spotlights. A woman crossed herself, then apologized. "For a moment," she said, "I thought you were Jesus Christ." "Modom," he said, drawing himself up to his towering tallness, "I am Arshile Gorky." And this was not arrogance. This was his devotion to a self-appointed mission. Art was Religion for Gorky, and in a museum God was in His Temple and Gorky was His Prophet.

His life may have been unhappy; or he may have chosen the climate of unhappiness as deliberately as he chose his own name, Gorky, the "bitter one."

He did not come to my Gallery directly to show me his own work. In the winter of 1932 he came urging me to look at the work of a friend of his named John Graham, and it was Graham who generously suggested that I also look at a portfolio of Gorky's own drawings. "My portfolio is already in your back office," Gorky reluctantly confessed, and my secretary told me that "that man is always leaving his portfolio in the back office. He comes back days later and pretends he had forgotten it."

"Yes," said Gorky shamelessly, "and I always expect you will have opened it and discovered masterpieces...." So I sorted through them now, and I answered Gorky gently. Because if I had not found masterpieces, I nevertheless thought I detected future greatness. I went down to Union Square with Gorky and looked at everything in his studio. I listened to his passionate discourses concerning the faded illustrations tacked on his walls, monochrome reproductions of Mantegna and Piero della Francesca and photographs of Ingres drawings. I listened to the woes of his financial disorder, and I lent him five hundred dollars. Later, when he couldn't repay, I bought some of his drawings. But I could not promise him an exhibition.

"Your work is so very much like Picasso's," I told him. "Not imitating," I said, "but all the same too Picassoid."

"I was *with* Cézanne for a long time," said Gorky, "and now naturally I am *with* Picasso...."

"Someday, when you are *with* Gorky..." I promised.

I had never before met a painter with the empathy to enter so completely into the style of another. I thought of the translations Moncrieff had made from the French of Proust. It was said that he memorized a dozen pages of Proust at a time, and then having completely absorbed the text he translated with no further reference to the original. And I remembered a concert given by Harold

Samuels playing the clavichord works of Bach shortly before a nervous breakdown which led to insanity and death. Samuels interrupted the performance of one variation. "I had not intended to write it that way," he said to the audience, proceeding then to play the fugue quite differently. He thought he was Bach.

"I hope Gorky will think he is Gorky," I murmured to myself, "before it is too late."

There was a long period after my first meeting with Gorky during which I saw little of him and nothing of his work, although he religiously visited all of my shows. His economic difficulties had been ameliorated by the W.P.A. for which he was doing projects in much the same manner as his earlier work.

What change of climate so suddenly provoked the rapid flowering of Gorky's genius, so long in germination? What conflicts of ideas, of cultures, of techniques had first to be resolved, and what finally deepened, released and affirmed his freedom after so protracted a period of absorbing, invisible growth?

Long ago there had been my book, *Surrealism*, published in 1936, which he straightaway read in the back room of my Gallery and soon borrowed to take home. I later found he had paraphrased several paragraphs of what was already a paraphrase by Paul Eluard, *Simulations*, translated in my book by Samuel Beckett, for use in love letters. And perhaps he listened while I told how Eluard confided to me one of his "systems" to stimulate the birth of a surrealist poem. "I hum a melody," said Eluard, "some popular song, the most ordinary. Sometimes I sing quite loudly. But I echo very softly in my interior, filling the melody with my own errant words." I can imagine Gorky telling himself one of his strange stories, reminiscing from his childhood "how my Mother's embroidered apron unfolds in my Life," and skillfully casting his linear nets to trap his images.

Then there was the year he had married, and with his new wife, Agnes Magruder, whom he called by a private name of affection, "Mougouch," he spent some time in the country and began to paint from nature outside of his studio. Perhaps this was not the first time he had painted from nature. There had been the period when he studied Cézanne, but had not really let the sunlight burn into his shoulders and the rain wet his palette. He had also been married before, but without the same passionate and jealous love he discovered with Mougouch.

There was much thought given to the problem of a class in camouflage he organized as a contribution to the war effort. The unconscious is, so to speak, the domain of camouflaged objects, and Gorky was to discover that if the realistic object can be camouflaged, so can the unreal, or "surreal" object be decoded and *decamouflaged*. He began, by some such liberating accident, to regard painting as a deliberate confusion rather than an analytic dissection. There was an emotional orgy in this liberation. For Gorky, automatism was a redemption. And it was also this new visceral freedom which brought him close to the Surrealists who were now in America—Ernst, Tanguy, Masson, and in particular Matta and André Breton. To understand Surrealism is to understand that an indispensable part of Gorky found meaning with the Surrealists who helped him both to bring himself to the surface and dig himself deep in his work. They made Gorky realize that his most secret doodling could be very central. He found his fantasy legitimized, and discovered that his hidden emotional confusions were not only not shameful but were the mainsprings for his personal statement, and that what he had thought had been his work had been just practice, and what had been his play was closer to his art.

I was in the army when Gorky thus became Gorky—and received the André Breton accolade. When I came out of the service Gorky soon visited me. He hoped that I would be re-opening my Gallery.

With high expectations I arranged successive

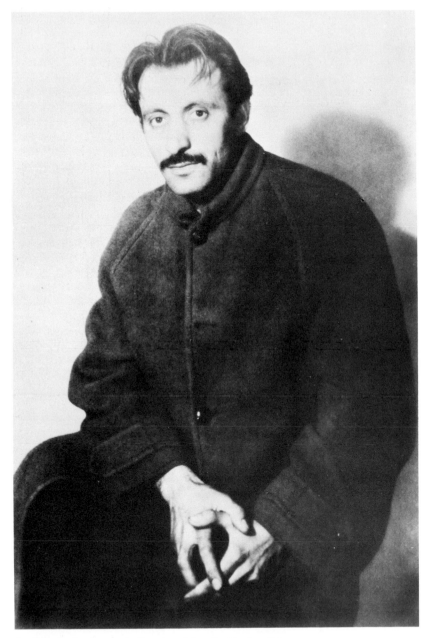

Arshile Gorky (c. 1933). Courtesy Mrs. Sarkis Avedisian

exhibitions of Gorky's new work and was his dealer during those last years, 1945 to 1948. The promise I had suspected in his early experiments seemed fulfilled. The arduous disciplines of tradition were exploding into the new, and the problem of the figurative versus the non-figurative was in process of solution. Here were the "hybrids" which André Breton described as "the resultants provoked in an observer contemplating a natural spectacle with extreme concentration, the resultants being a combination of the spectacle and a flux of childhood *and other memories....*" And appearing again, "You and the splendid blindman who shadowed you/The figurative and the non-figurative..." in Breton's moving poem, "Farewell to Arshile Gorky."

For Gorky was to die of many kinds of discouragements.

After carefully and curiously trying half a dozen favored spots in which to die (several nooses were found) on hilltops with a view or in intimate valleys with the trees and hillocks pressed close-up to his face, Gorky finally chose the rafters of a little woodshed in Connecticut where he was found swinging nearby a wall-board on which he had chalked: "Goodbye My Loveds."

As, during the last five important and outrageously melodramatic years of his life, after curiously and carefully trying half of a dozen favored modes in which to paint—experiments with the landscapes of Cézanne, the line of Ingres, the composition of Uccello, the logistics of Picasso, the floating humors of Miró—Gorky finally found the "Eye-Spring" of Gorky from which to draw his triumphant contribution to Life, which might be written: "Behold My Loveds."

His tragedy was that he felt himself three times rejected: in his love, in his health, and in his art. Any two of the three rejections he might have resisted, but the three together were not endurable. Here I will not speak of his love—a tougher man would have substituted another; nor of his health —the cancer which had gnawed part of him had

been removed and the broken neck from a recent automobile accident was healing. I would rather speak only of his art, as this is an occasion when a new generation will be looking with fresh eyes at his work.

Modern science has done much to heal jealousy and a broken heart in psychiatry, and to heal a broken neck in traction, but unrequited art is still met by that cruel and banal cliché, "Only time will tell...." After arduous years of self-imposed apprenticeship Gorky was vastly impatient. The indifference of some critics, important collectors and museums affected him deeply. He might have understood the disparagement of old companions who resented his flight beyond their orbit. But he could not accept the uncondensed time-lag between the artist's statement and his public appreciation.

In the eyes of the polite public the final, savage, revolting discoveries are made by monstrous and uneven men, while the refinement and assimilation into a social credit falls to the schools and followers. So it is Freud or Einstein who will shock the world to conceive the inexplicable formula— and then the numerous educated disciples will prove, interpret, and utilize the new knowledge in translations of very evident power. Gorky was an uncoverer and prospector of a new Space, a psychological Space. Alone, he strangled in it. And our admirable New York School of Art, which has become International, is part, but only part, of his unlimited Estate.

Today there are new formulae for time and space. We travel fast and must master these new formulae before they master us. Today nothing is too fantastic either for the body or for the spirit. And so perhaps, bringing with us a fraction of Gorky's devotion, we should attempt a new flight of the perceptions towards the more rapid recognition, the almost instantaneous comprehension— not of everything new but of anything great.

JULIEN LEVY *Paris, 1962*

Gorky's paintings and drawings fall naturally into two categories: the portraits, few in number, similar in style, and all but contained within the decade 1926-36 (pp. 14-19); and the much larger, less homogeneous body of his other work. This second group falls into three periods: self-imposed apprenticeship in the twenties (pp. 11-13); the thirties (pp. 20-27), during which his eclecticism finally coalesced into an original and personal style; and the great final period (pp. 28-50), beginning in the summer of 1942, during which Gorky produced his finest drawings and his major canvases.

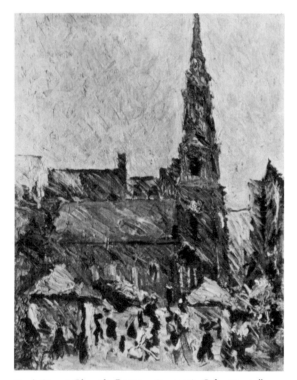

Park Street Church, Boston. (c. 1925). Oil, 16 x 12". Mrs. Edward M. Murphy, Lowell, Mass.

Landscape, Staten Island. (1927-28). Oil, 32 x 34".
Mr. and Mrs. Hans Burkhardt, Los Angeles

Still Life. (c. 1927). Oil, 20 x 24". Estate of Arshile Gorky

I The Twenties

On March 1, 1920, Vosdanig Manoog Adoian, a sixteen-year-old Armenian immigrant, disembarked at Ellis Island with his younger sister, Vartoosh. By 1930 he had become Arshile Gorky, an accomplished, if still imitative, painter. His first few years were spent in Boston, Providence and Watertown, Mass., where his father lived. He attended art classes in New England but learned more, it would appear, through absorption in self-imposed problems inspired by trips to museums (which he frequented constantly throughout his life), and by reproductions and books. By virtue of great natural skill, commitment, and an infallible instinct for recognizing primary styles and masters, Gorky conducted his own apprenticeship.

Park Street Church, Boston was painted in 1925 or before. This little impressionist cityscape, and the beautifully painted *Beach Scene* (cat. 1) make it apparent that Gorky looked at the world as well as at art, and that he already knew that pigment could be an independent language. In 1925 he moved to Greenwich Village, and almost immediately became an instructor at the Grand Central Art School. *Landscape, Staten Island,* painted in 1927-28, makes it evident that he dipped deeply into the crucial lessons about nature, light, bulk, line and color given by Cézanne to Western artists —lessons for which Gorky, having already practiced the method of Monet and Pissarro, had the prerequisites. As much can be said for *Still Life,* which was preceded by paintings of objects and figures in which he wrestled with the challenge postimpressionism once posed to detailed realism. In eight years Gorky painted his way from impressionism, through a profound emulation of Cézanne, and was ready to embark on the conquest of cubism. He had already begun to liberate himself from the subservience of his senior colleagues to academic literalism in favor of meaningful shapes, creative color and independent line.

above: *Composition.* (c. 1928). Oil, 43 x 33".
Mr. and Mrs. I. Donald Grossman, New York

above right: *Abstraction with Palette.* (c. 1930).
Oil, 47½ x 35½". Philadelphia Museum of Art

right: *Still Life.* (1929). Oil, 47 x 60". Estate of
Arshile Gorky

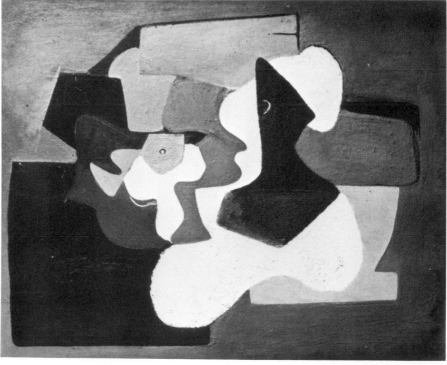

Gorky praised Stuart Davis as a painter "who realizes his canvas as a rectangular shape with [a] two-dimensional surface plane," who "forbids himself to poke bumps and holes upon that potential surface." What Gorky valued in Davis' work is what he also borrowed from cubism, if only temporarily: the idea that painting is the establishment of flat, essentially parallel, overlapping and hard-edged planes of color which may refer to actual objects, but are independent of them.

The twentieth century sets a higher value on unqualified originality than have other periods. A painter of the Renaissance spent his youth learning the technique and style of the master to whom he was apprenticed; in the Orient even today the ability to paint in established styles, and to understand time-honored subjects, precedes the assertion of an individual manner. It must be granted that Gorky's canvases of the twenties are imitative and sometimes bad, and that his link with great precursors was that of a provincial disciple. But it is also evident that these pictures are not the work of an *arriviste* who trafficked in other men's creations, but the homage of a reverent student who, in 1926, believed Matisse and Picasso to be greater than the old masters, and Cézanne to be "the greatest artist...that has lived" (bibl. 23, p. 125). Gorky possessed the rare combination of self-assurance and self-effacement, and, as Stuart Davis wrote, "the intelligence and energy to orient himself in the direction of the most dynamic ideas of his times" (bibl. 8, p. 28).

But Gorky's own achievement was also apparent before 1930. In this abstract still life, signed and dated 1929, the representational skin of cubism has already been peeled. The surface is thick with repeated overpaintings and revisions, and rough as a scratch coat of plaster; but the somber orchestration of geometric and biomorphic shapes in saturated tones of blue, red, black, tan and beige is totally successful. Within the cubist discipline, Gorky's dialectic of precision and abandon, preparation and improvisation, color and line —which he was to carry to brilliant fulfillment after 1942—is already eloquently stated.

The twentieth century—what intensity, what activity, what restless energy! Has there in six centuries been better art than Cubism? No. Centuries will go past—artists of gigantic stature will draw positive elements from Cubism.

Arshile Gorky, 1926 *(bibl. 12, p. 213)*

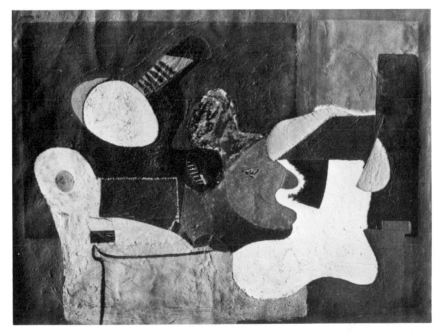

Still Life. 1929. Oil, 36⅛ x 48⅛". Jeanne Reynal, New York

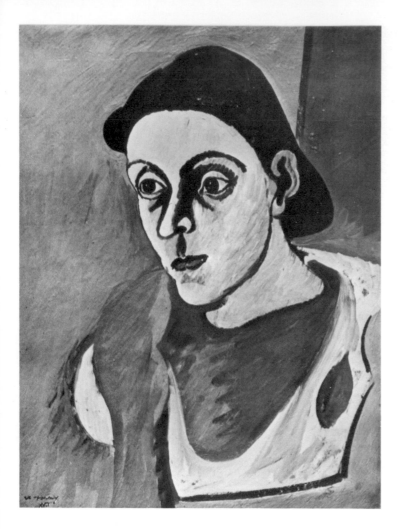

II Portraiture (c. 1926-36)

Gorky admired the large expressive eyes of the Armenians. One can see them not only within his own family, but in medieval religious paintings and manuscripts which Gorky, whose lineage included generations of priests, probably saw as a child near his native village of Khorkom Vari Haiyotz Dzor. Later in American museums he saw Russian icons, and discovered the immense eyes in Sumerian and Hittite art, which he identified with his Caucasian heritage. Again, he found exaggerated eyes in the drawings and paintings of Picasso and Ingres. He had a large photocopy of an Ingres self-portrait in his studio, and a cast of a Hellenistic female head from which he drew huge, simplified details of the eye and its setting. Gorky's fixation on the eye appears not only throughout the portraits, but also in the abstract pictures of the thirties.

The head of Vartoosh, sensuously brushed in a soft green-blue tonality, shows his admiration for Picasso's blue period, and perhaps for Matisse's fauve heads. It is brilliantly summarized and unhesitatingly painted. Like his self-portrait of the same period, it is infused with the mood of unfulfilled longing that pervades Gorky's art and life.

opposite: *Self Portrait.* (c. 1937).
Oil, 55½ x 34". Estate of Arshile Gorky

Portrait of Vartoosh. (c. 1933). Oil, 20⅛ x 15". The Joseph H. Hirshhorn Collection

right: *Self Portrait.* (c. 1933). Oil, 10 x 8". Rebecca and Raphael Soyer, New York

far right: *Self Portrait.* (c. 1935). Pencil, 9⅞ x 8¼". Ethel K. Schwabacher, New York

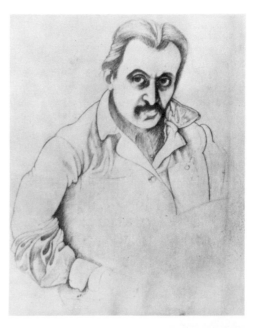

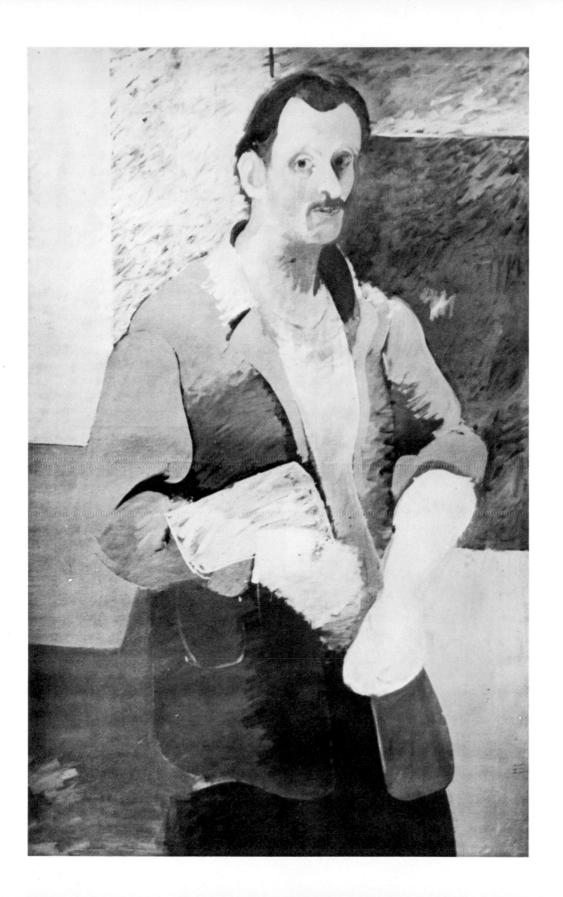

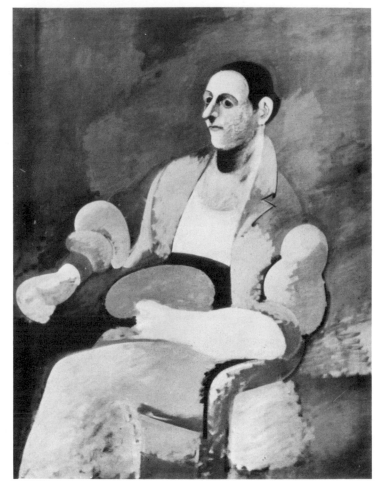

Portrait of Master Bill. (c. 1937). Oil, 52 x 40⅛". Estate of Arshile Gorky

Because the demands of portraiture tend to conflict with postcubist style, some contemporary painters and sculptors work more traditionally in their portraits. Gorky's portraits (except for a very few studies of the forties) are homogeneous in treatment and consistent in direction. Poses are simple, facial expressions are intent and meditative, eyes are large, and flesh tones, as Ethel Schwabacher has pointed out (bibl. 27, p. 36), often have an otherworldly pallor. Backgrounds are flat and generalized, adding to the metaphysical detachment of the sitters. Most often Gorky seems to have begun with a careful pencil drawing, but the paintings are sweepingly simplified, with the Ingresque minutiae of the study supplanted by modulations of tan, cream, mars violet, or tinted grays. Brush textures, partial overpainting, or adjustments of area against area begin to compete with faces; hands, arms and costumes, their detail scraped away or buried, are pressed into the surface. In the unfinished *Portrait of Master Bill,* painted in warm grays and ochres, the organic unity of a human figure begins to disintegrate in the humanoid shapes to which it gave rise; arms and sleeves detach themselves to become abstract ovoids. Gorky never continued on this path from portraiture toward organic abstraction: it was for Willem de Kooning to explore it to the end.

THE ARTIST AND HIS MOTHER (c. 1926-36)

Gorky is said to have begun this double portrait in 1926, and he continued work on the final version until at least 1935. The motif was provided by a photograph of himself and his mother posing in front of a painted backdrop, taken in 1912 when Arshile was eight years old, to send to his father in the United States. First, in two quick pen sketches on the same sheet, the composition was established. By contrast, the larger drawing in pencil is painstakingly studied. Selected passages are deeply modeled, following the example of Picasso's neoclassical works of 1918-1922. It is marked off with numbered squares—a traditional method of enlarging drawings used repeatedly by Gorky after 1944. Although one cannot say positively, the painting that conforms more closely to this working drawing is probably the earlier.

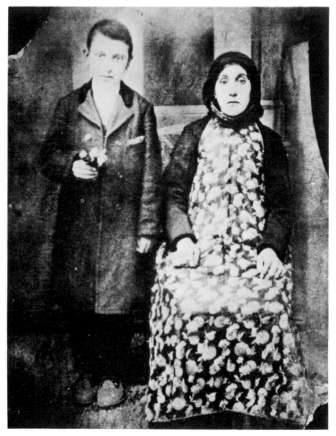

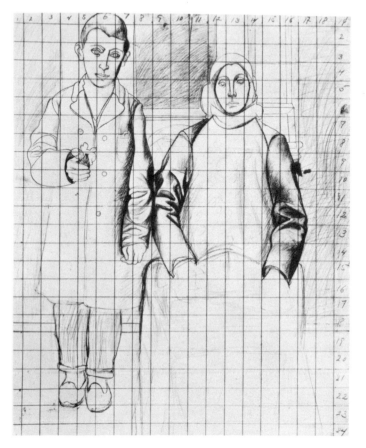

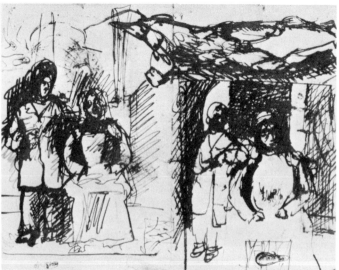

Photograph of Gorky and his mother. Armenia, 1912.
Courtesy Mrs. Sarkis Avedisian

above right: *The Artist and His Mother*. Pencil,
24 x 19". Estate of Arshile Gorky

below right: *The Artist and His Mother*. Two studies:
Ink, 8½ x 11". Estate of Arshile Gorky

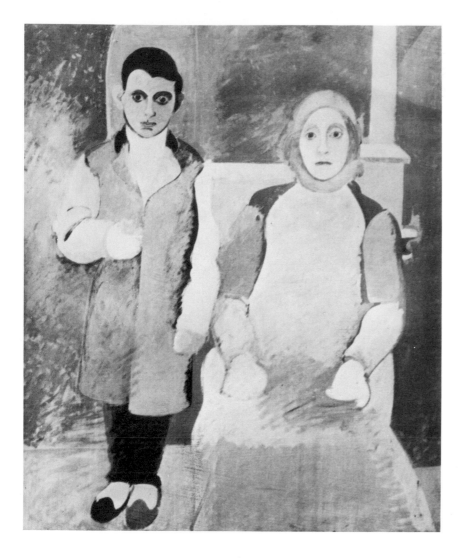

The Artist and His Mother in the Whitney Museum of American Art is unquestionably Gorky's finest figure composition. That it is probably the final version is attested not only by its more advanced state, but by its abstracted background, which cuts out foreground shapes negatively, overlapping them from the outside. By scrapings and reapplications of thin pigment, Gorky gave his surfaces the soft glow of old marble or porcelain. The colors are uniformly cool and muted distillations of ochre, blue, green, and mahogany. Wan but delectable, this scheme emphasizes the hieratic dignity and masklike intentness of the mother's face. The figures are stiff and solemn; and lack of modeling, obliteration of detail and uncompleted passages of brushwork dematerialize whatever corporeality remains in the faded photograph: the modulated color patterns seem weightless, undisturbed by the subjects they depict.

The Artist and His Mother is the climax of Gorky's figure painting. It is one of the rare masterpieces of modern portraiture, worthy of comparison with Picasso's *Gertrude Stein* or Kokoschka's *Herwarth Walden*.

left: *The Artist and His Mother*. Oil, 60 x 50".
Estate of Arshile Gorky

opposite: *The Artist and His Mother*. Oil, 60 x 50".
Whitney Museum of American Art.
Gift of Julien Levy for Maro and Natasha Gorky in
memory of their father

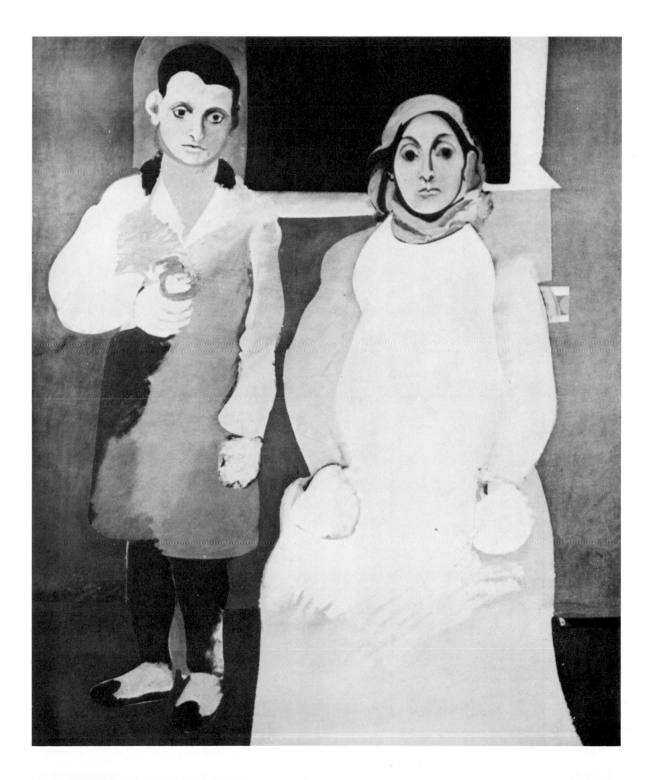

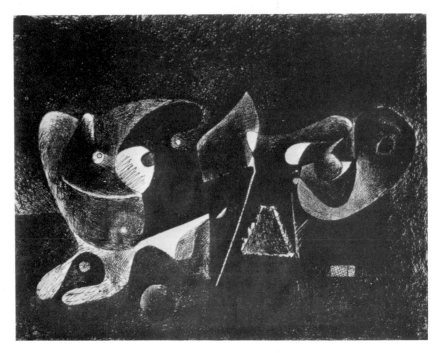

III The Thirties

NIGHTTIME, ENIGMA AND NOSTALGIA (c. 1931-34)

Like many other New York artists, Gorky was very poor during the early years of the Depression. Instead of oils he produced a striking series of drawings. The "Nighttime, Enigma and Nostalgia" motif was obsessively redone in more than twenty almost identical versions, in several variations, and in combination with other images. Most of the drawings are rendered in a painstaking but feverish ink hatching. Gorky must have gone frantically from paper to paper, for many were abandoned—in disgust it would appear—when the line smeared or blotted; some are scarred with scratched strokes like those used to cancel exhausted etching plates. One cannot say with assurance why Gorky was so engrossed with this image. What remains of the cubist vocabulary is its architectural setting and placement, and an interlocked complex of curved shapes that resemble an artist's palette with its eye-like perforation, or the patterns that in cubist still life function as shadows, or represent bowls, musical instruments and gourds.

At this time Gorky went farther than Picasso in the direction of biomorphic abstraction, which he must have seen also in the work of Arp, Miró, and others. Almost no reference is made to objects, so emotional content is free to become the subject. As the title "Nighttime, Enigma and Nostalgia" (which would fit an early work by de Chirico) indicates, the mood is somber and dreamlike. This theme is pure Gorky, an artist for whom "the vital task [to use the words of the painter Adolph Gottlieb] was a wedding of abstraction and surrealism." (bibl. 13) The series concluded with one painting in color, another in black and umber.

top: Drawing. (c. 1931-32). Ink, 12¾ x 21¾"
Mr. and Mrs. Philip Gersh, Beverly Hills

above: Drawing. (c. 1931-32). Black and brown ink,
21⅝ x 28". Ethel K. Schwabacher, New York

right: Drawing. (c. 1931-32). Pencil, 22½ x 29"
Martha Jackson Gallery, New York

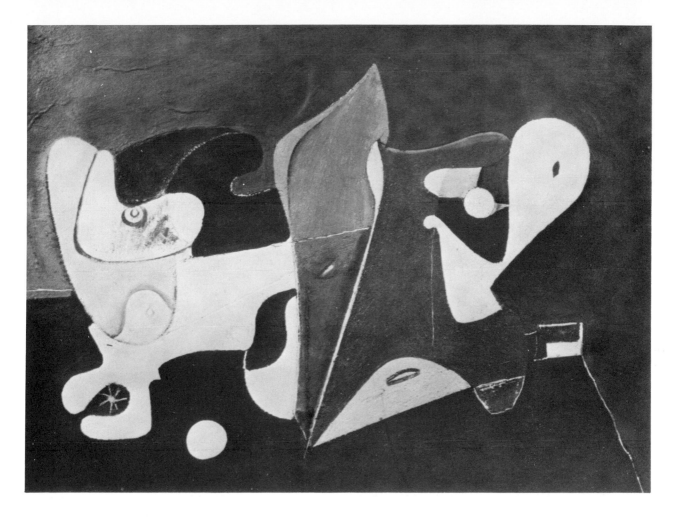

above: *Nighttime, Enigma and Nostalgia.* (c. 1934). Oil, 36 x 48". Martha Jackson Gallery, New York

left: Drawing. (c. 1931-32). Ink, 22 x 30". Estate of Arshile Gorky

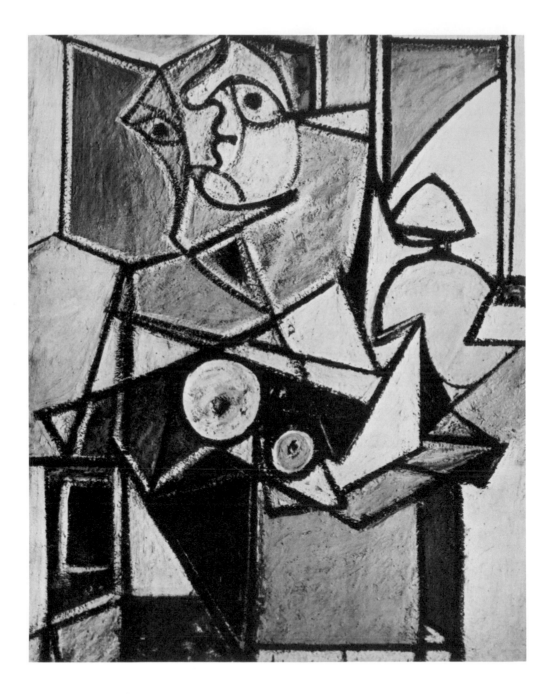

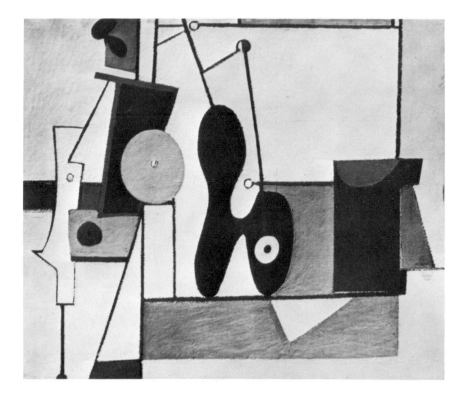

A review of an exhibition of Gorky's drawings at
the Guild Art Gallery in 1935 commented that his
"soft, indeterminate, romantic treatment [is] the
antithesis of Léger's decorative style." It is true
that organic, rhythmically interlocking abstraction
was his most characteristic expression. Yet at just
this time Gorky was working on mural designs
for the Newark Airport which were strongly in-
fluenced by Léger's geometric style, and his bio-
morphic predisposition was interrupted by a group
of rectangulated compositions. But *Organization*
and *Composition with Head* derive far less from
Léger than from Picasso's studio interiors of 1927-
28, in which figures and still life are abstracted
into ordered patterns of white, gray and flat col-
ors. Following Picasso, Gorky clamped his planes
into position with dark bars. The surfaces between
have been recoated so many times that the pig-
mentation rises in hills and sinks in depressions.
The larger canvas, painted in grayed whites, jade
green, yellow, tan and vermilion, is so heavy that
two men can barely lift it. The black bands sepa-
rate the layers of impasto, as Elaine de Kooning
wrote of the works of this period, "like valleys"
(bibl. 9, p. 64).

Where masters he specially admired were con-
cerned, Gorky paid little heed to anyone who criti-
cized him for imitation. As many recorded remarks
demonstrate, he identified with Picasso so empath-
ically, worshiped him so unequivocally, that such
criticism seemed to him absurd. In painting, as in
his loves and friendships, Gorky's commitments
were total. And derivative though these works are,
they stand on their own; in retrospect one can see
the breathing shapes, the ideographs of eye or
breast, the high emotional tension that continued
to be hallmarks of his painting. Gorky detested
the use of a ruler, and these works are his closest
approach to geometric abstraction. But as a result
of his period of cubist discipline, the freest of the
later paintings retain a sense of order.

above: *Organization.*
(c. 1934-36). Oil, 49¾ x 60".
Estate of Arshile Gorky

left: *Composition with Head.*
(c. 1934-36). Oil, 78 x 62".
Estate of Arshile Gorky

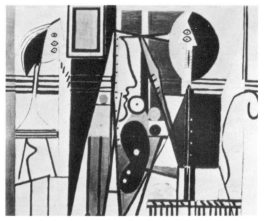

Picasso: *Painter and Model.* 1928. Oil, 51⅝ x 63⅞".
Mr. and Mrs. Sidney Janis, New York

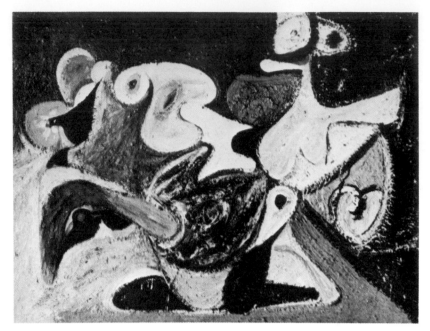

Image in Xhorkom. (c. 1936). Oil, 32⅞ x 43". Jeanne Reynal, New York

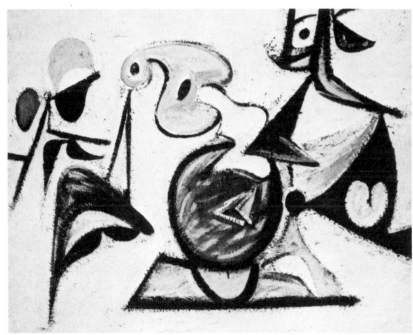

Xhorkom. (c. 1936). Oil, 40 x 52". Estate of Arshile Gorky

IMAGE IN XHORKOM (1936)

This title derives from "Khorkom," the name of the Armenian village in the province of Van where Gorky was born. In 1936, returning from geometric composition to one of the more sculptural of his earlier drawings, he continued to enrich his most personal tendencies. Like other works of this time, three of the four versions of *Image in Xhorkom* are heavily pigmented as a result of his habit of extracting from one line scheme a succession of images—most of which were subsequently buried —by recoating the same areas with new hues and values. The individual paintings are different in composition, however, as well as in color, texture and relief. In addition (initiating a practice almost always followed in his late work) architectural lines and planes were added, to anchor and provide a setting for the interlocking shapes. The weaving filaments of the drawing were omitted, perhaps because Gorky had not yet worked out a means of translating fine lines to paint.

The forms have many symbolic references: any one familiar with Gorky's development can discover abstracted birds, leaf shapes, and the ubiquitous palette and eye motifs. But, as in the upper version, these recurrent images are also masks (which they sometimes resemble) obscuring the rounded shapes that, from Ingres' *Turkish Bath* until the aggressive eroticism of Miró and Dali, relate to the female body. Interlocked with phallic projections, they have the generalized concreteness of a dream; and it is quite apparent that the abstract, hard-edged configuration at the upper right of the drawing has become a voluptuous, large-breasted nude. The effect is greatly changed in the lower canvas, which is painted in bright colors against an open white background.

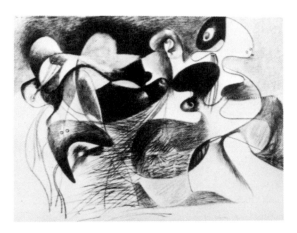

right: Study for *Xhorkom.* Pencil, 19 x 25".
Estate of Arshile Gorky

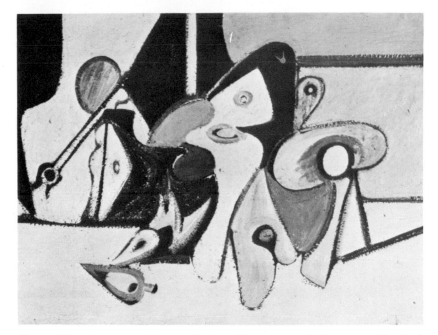

Composition. (1936-37). Oil, 36 x 48". Mr. and Mrs. I. Donald Grossman, New York

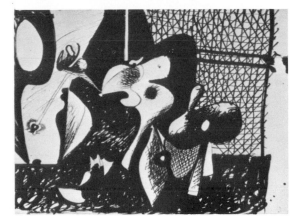

Study for *Painting.* Black and brown ink, 10 x 15".
Mr. and Mrs. Hans Burkhardt, Los Angeles

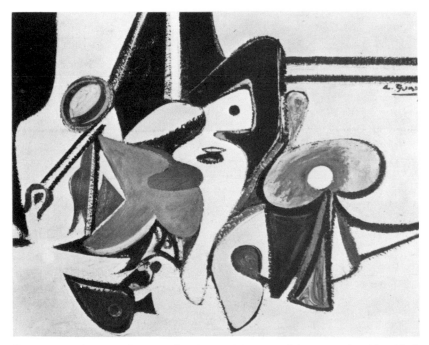

Painting. (1936-37). Oil, 38 x 48". Whitney Museum of American Art, New York

PAINTING (1936-37)

Painting, purchased by the Whitney Museum in 1937, was Gorky's first work to enter a major public collection. It is one of several variants differing in color scheme, and derives, like the "Xhorkom" pictures, from the intensive years of drawing that came before. It is identical in size and proportion to the black-and-brown oil, *Nighttime, Enigma and Nostalgia.* An architectural drawing by Gorky exists which includes both compositions, carefully rendered in his crosshatched ink technique, as overdoor murals symmetrically flanking a central platform.

In scale, arrangement and setting (as the rough pen sketch makes clear) this is a still life. A table top, rear wall and moldings, recalling the cubist paintings of the twenties, can be identified; the central group resembles an arrangement of plants, vases and such objects, with leaves strewn on the table or projecting downward. Note also the curious tridentlike object at the left, containing a dot, which becomes a tassel or bird's head in the paintings. But of more value than seeking the origin of each unit is an understanding of Gorky's metamorphic method. As he proceeded he was willing to substitute any one ideogram for another, or to abandon it completely. Instinctively, he seems to have been moving toward the realization that a given configuration can resemble, let us say, a leaf, the wing of a bird, or a pointed Armenian slipper: that behind the practical catalogue of specific objects and organisms lies a convergent vocabulary of universal forms.

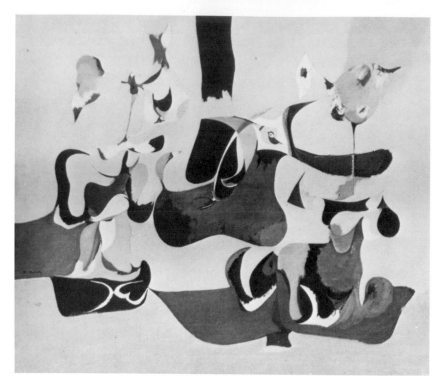

Garden in Sochi. (1940). Oil, 25 x 29". Estate of Arshile Gorky

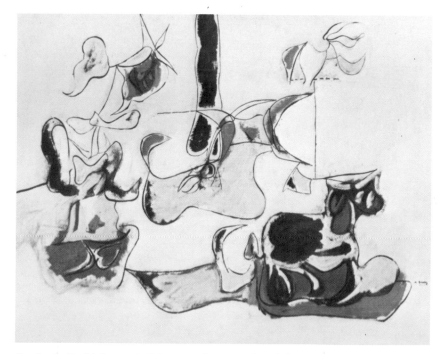

Garden in Sochi. (c. 1941). Oil, 31 x 39". Estate of Arshile Gorky

opposite: *Garden in Sochi.* (1941). Oil, 44¼ x 62¼".
The Museum of Modern Art, New York. Purchase Fund
and gift of Wolfgang S. Schwabacher (by exchange)

GARDEN IN SOCHI (1940-42)

At least six works, of which the canvas in The
Museum of Modern Art is the most ambitious, re-
late to this theme. Although Gorky affixed to his
title the name of Sochi, the Russian resort city on
the north shore of the Black Sea, "The Garden
of Wish Fulfillment" was in fact a part of his
father's farm on the shore of Lake Van. It was an
uncultivated orchard that had become overgrown
and heavily shaded. In it, Gorky recalled, was a
large dead tree, and a blue rock emerging from
black earth and moss, both of which were believed
by the villagers to have supernatural powers. On
"The Holy Tree" were fastened strips which pass-
ers-by had torn from their clothing, and women
came to rub their bared breasts against the rock—
a means, it would appear, of inducing fertility.

The alchemy of Gorky's memory and imagina-
tion blended this romantic image with another
from Renaissance art: large color reproductions of
the three surviving panels of Paolo Uccello's *Battle
of San Romano* hung on the wall of his Union
Square studio. In *Garden in Sochi* he merged the
multicolored ex-votos fluttering in the breeze,
Uccello's heraldry of banners, lances, harnesses
and costumes, the contact of yielding flesh against
hard blue rock, the abstract patterns of a master
he loved, and the sight and sound of rustling silver
leaves, in a composite image.

In the first version, which shows the dominant
influence of Miró, one can identify a tree trunk at
upper center, the blue rock at the left, the waving
strips of clothing, and a playful animal—Gorky
mentions porcupines in his comments (bibl. 27, p.
66)—at the lower right. Ethel Schwabacher has
also called attention to the exotic slipper form at

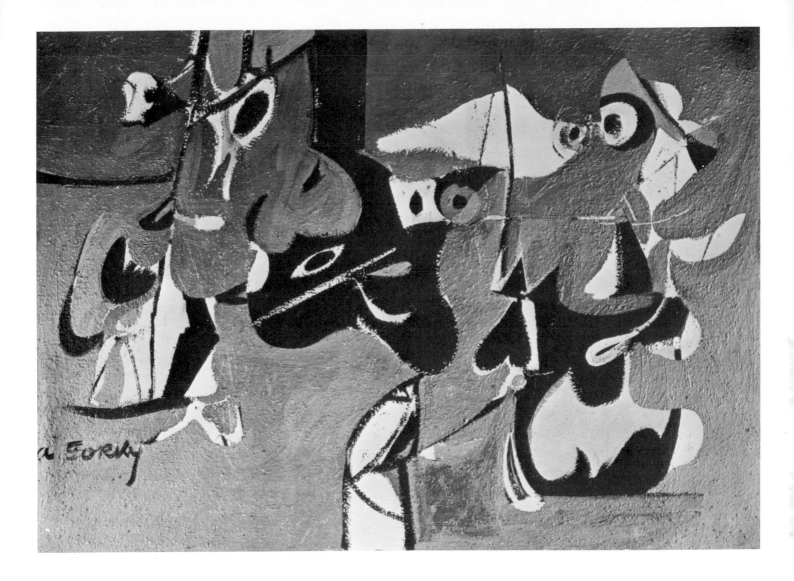

the center, with its fantastic pointed toe, and toward the right a singing bird. Miró is not the sole source for such shapes: bright flat colors and the sharp pointed forms of slippers, draperies and banners, as well as abstracted birds and animals, can be found in Armenian manuscripts from the province of Van. Moreover Gorky loved birds, dogs, cows, flowers and plants—in fact all living things that make up the bucolic environment, and they constantly recur in his later work. The second version reproduced is important because in it color and line are entirely separated in function: it is this technical premise that was to make Gorky's late style possible. The third version is the most fully synthesized. In direct placements of rich pigment against a thick earth-green field, it concludes the second period of Gorky's development.

The "Sochi" group marks several crucial readjustments, among them the absorption of Picasso's influence in that of Miró, which in turn, from first version to last, is finally assimilated; and the replacement of a close-up studio-and-still-life scale by a return to the proportions and ambiance of landscape. If Gorky after 1941 had remained solely in his New York loft where the sources of his art comprised reproductions, illustrated art books and magazines, the experiments of his friends and trips to museums, he might have been among the first abstract expressionists: The Museum of Modern Art's picture holds such a promise. But Gorky went directly to nature for inspiration in 1942. *Garden in Sochi* was therefore not only a technical culmination; by reviving his interest in landscape, it was also an ideological rebirth.

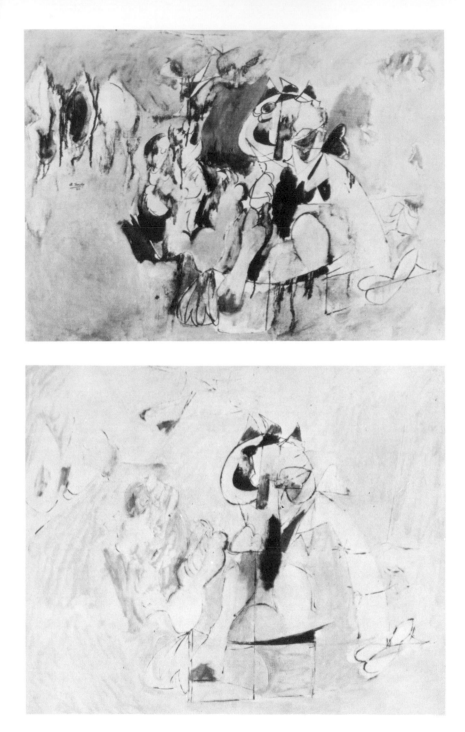

IV Nature (1942-48)

THE PIRATE (1942-43)

One of the last "Sochi" paintings bears the specific date of April 17, 1942. During the next summer Gorky and Agnes Magruder, who had married in September and were expecting a child, spent three weeks in the Connecticut countryside. After years of poverty, frustration and loneliness in the dust of downtown New York, Gorky experienced the triple awakening of love, the promise of a family, and a return to the bucolic environment he looked back to so nostalgically. In every sense of its promise "The Garden of Fulfillment" must have seemed actual.

Among first indications of the radical redirection of Gorky's painting to come are two versions of *The Pirate*, painted the following winter. In spite of a puzzling title and the zoomorphic image at the right, the effect is of an ephemeral spring landscape. The pale colors—a range recalling the portraits of several years earlier—are tints of sap green, blue and violet, as in the water colors of Cézanne. In a sharp break from the "Sochi" pictures, the white priming is barely covered, and in *The Pirate I* Gorky allowed the liquid color to run unchecked down the surface of the canvas. *The Pirate II* is harder and more defined than the first version, and scraped transparency replaces wash. The two works share a common image, but they are not systematically developed from an initial drawing as are works painted a few years later. The "Pirate" theme was paralleled by several strong drawings combining the new vision of nature and the pen-and-ink technique of 1932 with bright colors rendered in wax crayon (cat. 50), and also by the idyllic *Waterfall* (cat. 47; bibl. 27, pl. II), which also exists in two versions.

top: *The Pirate I*. 1942. Oil, 29¼ x 40⅛".
Mr. and Mrs. Julien Levy, Bridgewater, Conn.

left: *The Pirate II*. 1943. Oil, 30 x 35".
Mr. and Mrs. Julien Levy, Bridgewater, Conn.

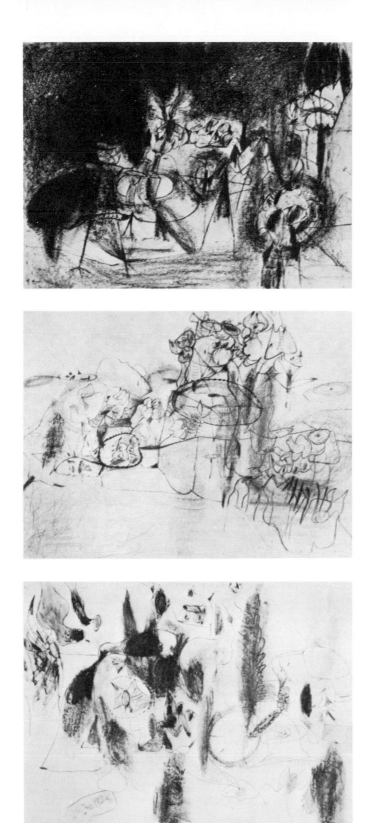

top: Drawing. 1943. Pencil and wax crayon, 20 x 26¾".
Mrs. David Metzger, New York

center: *Virginia Landscape.* (1943). Pencil and wax
crayon, 20 x 27". Mr. and Mrs. Stephen D. Paine,
Boston

bottom: Drawing. 1943. Pencil and wax crayon,
18½ x 23½". Mr. and Mrs. Stephen Hahn, New York

DRAWINGS (summer, 1943)

Again and again art has been revitalized by a re-
turn from abstraction to nature. This renewal can
occur historically or within the life of an indi-
vidual artist, as it did with Gorky. His renewed
contact with landscape, which began in 1942, was
consolidated during the summer of 1943, when
he and Agnes visited her father's farm in Hamil-
ton, Virginia. Here, taking a worshiper's delight
in the sun, Gorky produced some of the most orig-
inal and sophisticated drawings of his period.
With his pencil sharpened to a long, tapering
point, applying a technique schooled by his study
of Ingres and Picasso, he drew the life he saw "in
the grass." But Gorky, as he once remarked, "never
put a face on an image." While he scrutinized
botanical and biological organisms at close range,
another vision was directed inward and backward,
bringing into focus passages from the works of
artists he admired, moments of past emotional ex-
perience or points of pain, fear or sexual desire.
All these diverse levels and kinds of images joined
in his mind with the phenomena before him.

Gorky's unique morphological sense made him
able to see nature in visual metaphors rather than
generic categories. He saw universal shapes, con-
figurations and structures which were common to
flowers, insects, humans, crustaceans, and other
genera and at the same time expressive of his own
psychic pressures and processes. The image mu-
tated as he drew, controlled now by one, now by
another stimulus. The outcome, as André Breton
explained in his well-known "Eye-Spring" essay,

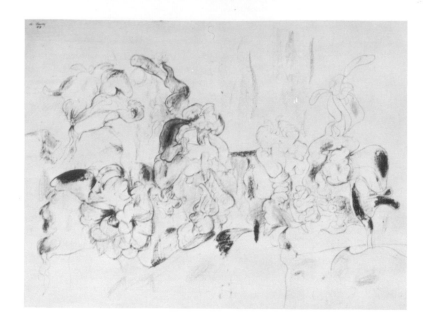

(bibl. 6), was a new order of "hybrid" forms. Gorky opened the prison of scientific categories by the "free unlimited play of *analogies*." But though the image vacillates, it is seldom diffuse. The details, delineated with surgical precision, convince us of their actuality: they are "real" things. Hairline distinctions are established between thoracic projections, fleshy masses, and clusters of fluttering membranes. A single contour can define the swelling of an anatomical bulge, delimit an abstract plane, and initiate a movement. The resultant ensemble of conflated appearances, as Harold Rosenberg writes (bibl. 23, p. 106), becomes "overgrown with metaphor and association. Amid strange, soft organisms and insidious slits and smudges, petals hint of claws in a jungle of limp bodily parts, intestinal fists, pubic discs, pudenda, multiple limb-folds...." "Here for the first time," Breton concluded in *The Eye-Spring*, "nature is treated as a cryptogram."

above: *Landscape*. 1943.
Pencil and wax crayon,
20¼ x 27⅜".
Mr. and Mrs. Walter Bareiss

right: *Anatomical Blackboard*.
1943. Pencil and wax
crayon, 20¼ x 27⅜".
Mr. and Mrs. Walter Bareiss

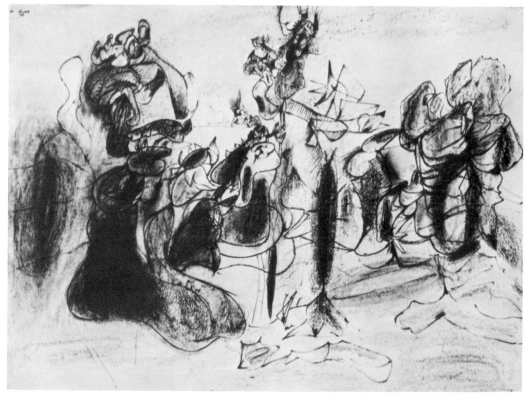

opposite: *Water of the Flowery Mill*. 1944. Oil, 42 x 48¾".
The Metropolitan Museum of Art, George A. Hearn Fund, 1956

Beginning in 1929, freely curved forms began to typify Gorky's style. Following this tendency he utilized the art of Picasso, Ingres, Miró or any other source that met the test of his acute mind and eye. Until 1940 his biomorphic forms (when they were not totally abstract) alluded to objects or figures; and whatever mutations they sustained, they remained more or less hard-edged or sharp-contoured. But when paint becomes so fluid that shapes begin to flow, as in *Water of the Flowery Mill,* lyrical abstraction begins to resemble water, light, clouds, or other volatile natural phenomena.

Gorky knew Kandinsky's early writings and abstract landscapes; Agnes Gorky affirms (bibl. 22, p. 228) that Kandinsky became "as important to Gorky as Picasso." Quite understandably, it was just at the time when Gorky was revitalizing his early feeling for nature that he accepted the influ-ence of Kandinsky, surrealist automatism and Matta. He was often with André Breton, Julien Levy and the surrealists in 1944, and the paintings of that year are his closest approach to unplanned improvisation: he went farther toward automatic painting that year, indeed, than most of the surrealists. But automatism was still only an ingredient in Gorky's art. Behind each sparkling performance one can sense his probing draughtsmanship. The drawings of 1943-46 almost always postulate a degree of finish beyond that of the resultant paintings. Occasionally Gorky proceeded part way toward his blueprinted goal with the logic of a neoclassicist; but brush once put to canvas, unexpected colors and combinations spoke to him, and washes of paint took the initiative in opulent rivers of gold, crimson or violet. Gorky the passionate improvisor was then able totally to ignore Gorky the scrutinizing draughtsman or Gorky the rationalist and traditionalist.

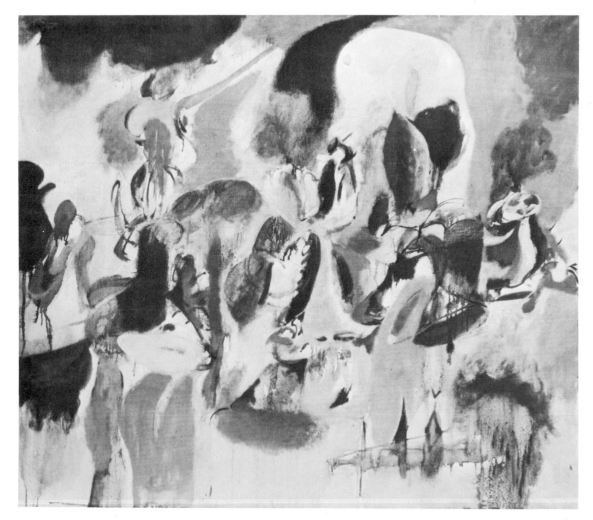

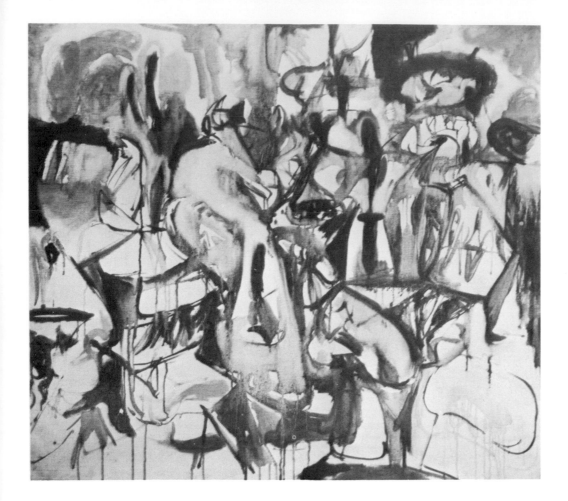

above: *How My Mother's Embroidered Apron Unfolds in My Life.* (1944). Oil, 40 x 45". Mr. and Mrs. C. Bagley Wright, Jr., Seattle

right: *The Leaf of the Artichoke Is an Owl.* 1944. Oil, 28 x 36". Ethel K. Schwabacher, New York

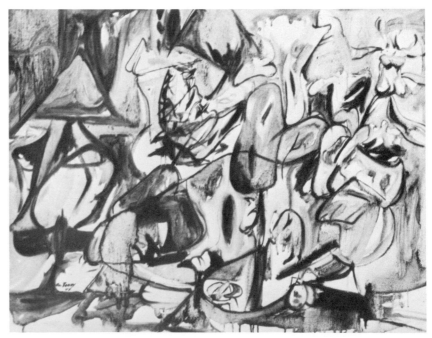

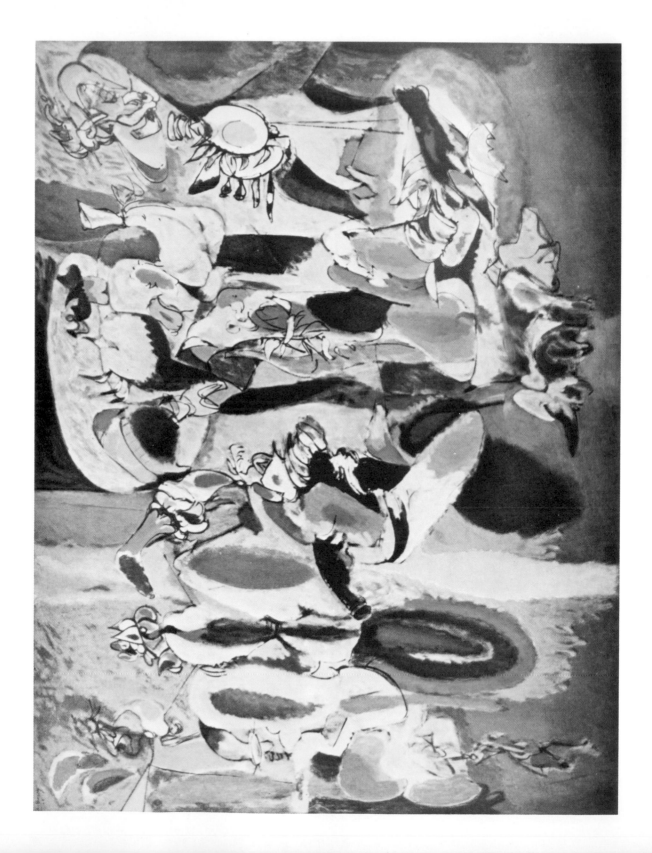

*"The song of a cardinal, liver, mirrors
that have not caught reflection,
the aggressively heraldic branches,
the saliva of the hungry man
whose face is painted with white chalk."*

A.G., 1944. (bibl. 18, p. 120)

The Liver is the Cock's Comb is the largest and
one of the most splendid of Gorky's paintings.
It is a lavishly enriched enlargement of a draw-
ing done in the summer of 1943. The control it
exerted over the final composition is quickly
demonstrated by a glance from study to paint-
ing. In beginning the canvas, craft was sub-
stituted for artistry: the drawing—a pulsating
record of direct observation—was carefully en-
larged to fit an exactly proportioned canvas
over eight feet wide; then the small smudges of
yellow, blue, red and green were closely
matched by pigment and placed in their as-
signed locations. Except that the canvas was
whiter than the buff paper it must have been at
one point almost a replica. The tall "plumes" of

color (for that is what Gorky called them) were
interpreted more freely, for they are not con-
fined by pencil contours. At this point Gorky
the artist took over once more, building a set-
ting of low-keyed planes in tertiary colors
around the line-and-crayon landscape of the
study. Then aureoles of yellow, blue–violet and
blood red were added and the plumes were re-
inforced to create independent shapes, making
the original primary accents sing out with stun-
ning purity—a range of color no doubt influ-
enced by Kandinsky. Gorky reinforced chosen
contours: what began as a landscape now has,
in part, the effect of an interior enclosing a
ritual performed by fantastic personages and
mysterious objects.

Some of the hypnotic power of both drawing
and painting derives from the ambiguity of their
multiple imagery. The drawing is a perplexing
but razor-sharp depiction of the fragile but cruel
fertility of nature. It is easy to find analogies
between these averted botanical and biological
organisms and human reproductive organs and
acts. But in the end the conflated details of
Gorky's cryptogram confound the most curious
mind, forcing it to face its own preoccupations.
So dominating and heraldic is the large paint-
ing however that, as under the impact of the
sounds, colors and movements of a barbaric
ballet, one's senses are too overcome and de-
lighted for such visual research.

Some of Gorky's titles, such as *Garden in Sochi* or *The Plough and the Song,* are entirely his own, and allude to deep past experiences. Others were conceived in conversations with his dealer Julien Levy, André Breton the surrealist poet, and other friends. A few are simply descriptive, and others such as *The Pirate* are all that remains of a subject almost forgotten as the picture developed. The origins of some are not known. With few exceptions they are poetic, evocative, and often strangely appropriate, but are usually no more susceptible to analytical explanation than the hybrid images are to precise identification.

Should the levitated bodies at the right of *Good Afternoon, Mrs. Lincoln* be read as odd personages meeting in conversation? Toward the upper left: did Gorky envisage a long-haired female figure leaning forward and gesturing with truncated arms over a gnarled landscape? One cannot say without prior knowledge, for no two spectators will decode Gorky's allusions in the same way. Perhaps one understands him better by not trying to pierce his camouflage. Yet this composition, like many others, is permeated with its unique savor—specific but unnamable, like the taste of absinthe; and surely the total effect is that of a landscape.

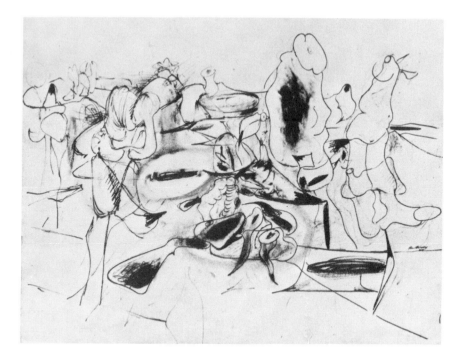

Study for *Good Afternoon, Mrs. Lincoln.* 1944. Pencil and wax crayon, 20 x 26". Mr. and Mrs. Julien Levy, Bridgewater, Conn.

right: *Good Afternoon, Mrs. Lincoln.* 1944. Oil, 30 x 38". Estate of Arshile Gorky

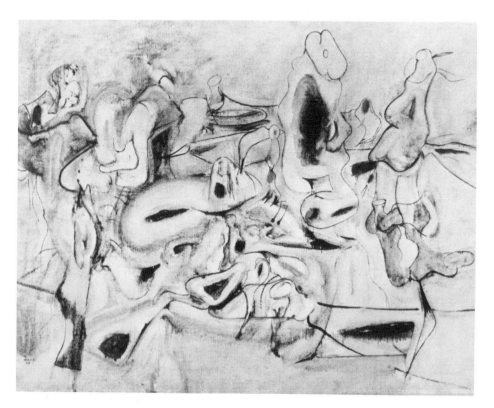

1945

No contemporary painter has equalled Gorky's easy uniformity of brush line—at once relaxed and controlled—which is a distinctive mark of his late style. As a moment's comparison of drawings to paintings will show, his painted line is a direct translation from pencil. Such a line, which never takes on the thickening and thinning of calligraphic brushwork, is impossible with traditional painting tools.

Harold Rosenberg (bibl. 23, p. 68) recounts Gorky's introduction to the thin, long-haired brush known as a "liner," used by sign painters.

One day de Kooning found Gorky unsuccessfully struggling to produce long lines with "fat Rubens brushes," and was amazed to discover that Gorky did not know a brush had been expressly designed for that purpose. "Having bought one," de Kooning remembers, "Gorky sat around all day in an ecstasy painting long beautiful lines." Yet this brush—the perfect tool to translate his line from pencil to pigment—was not fully exploited by Gorky until 1944 after the completion of "The Liver," in which contours are drawn with conventional brushes. Taking full advantage of his extraordinary dexterity, Gorky was then able to produce precise, but more fluid and mellifluous, oil enlargements of his pencil drawings. This innovation, of the utmost importance for his later work, had an immediate effect on the works of 1945. Some of them, painted in transparent wiped washes on otherwise bare white canvas, are in fact large drawings. The lines streak across their surfaces like the blades of an ice skater, fluently delineating configurations Gorky had originated previously in drawings. Line retained its importance for him, but he was never again to allow it such dominance over other pictorial means.

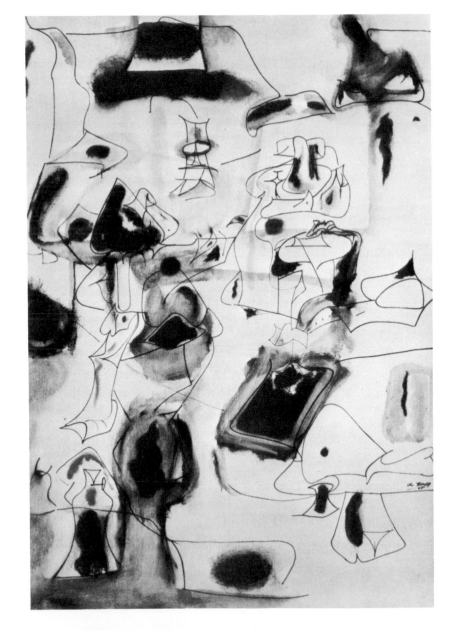

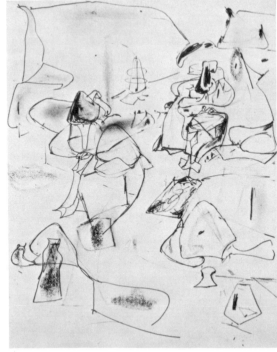

Study for *The Unattainable*. (1945). Pencil and wax crayon, 24 x 18". Estate of Arshile Gorky

left: *The Unattainable*. 1945. Oil, 41¼ x 29¼". Barney Rosset, New York

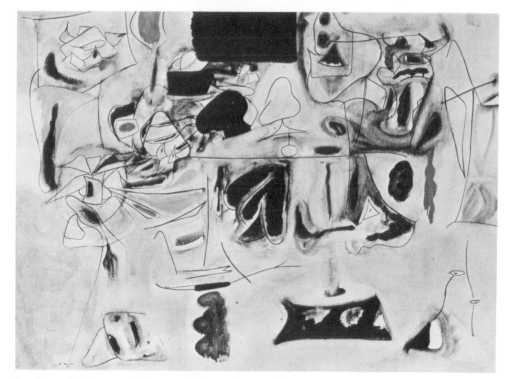

Landscape Table. 1945. Oil, 36 x 48". Mr. and Mrs. B. H. Friedman, New York

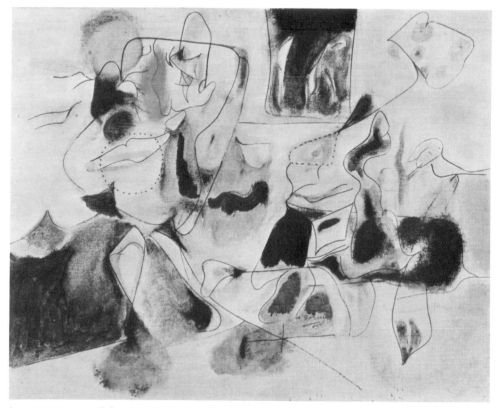

Impatience. 1945. Oil, 24 x 48". Dr. and Mrs. Israel Rosen, Baltimore

Gorky and his family had the Crooked Run Farm in Hamilton, Virginia to themselves in the summer of 1946. As he convalesced from an operation, he once again drew in the fields during the day, and before the fireplace in the living room during the evening. He returned from Virginia with 292 brilliant drawings: those done outdoors carry forward the principles initiated in 1943, while the "interiors," influenced by Matta, add a tragic *dramatis personae* in which the anatomical members of furniture fuse with those of human beings. Afterward Gorky's imagery is often poised between these morphological alternatives, as his themes are between joy and pain.

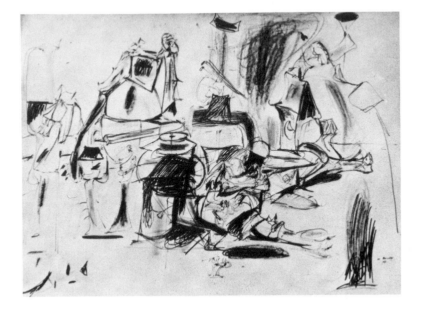

opposite above: Drawing. (1946). Pencil and wax crayon, 19 x 25". Mrs. Herbert Ferber, New York

opposite below: Drawing. (1946). Pencil and wax crayon, 18⅞ x 24⅝". Ethel K. Schwabacher, New York. (This drawing is a study for the "*Pastoral*" group, catalog numbers 113-116)

above: Drawing. 1946. Pencil and wax crayon, 22 x 30". Estate of Arshile Gorky

right: *Pink Drawing.* (1946). Pencil and wax crayon, 19 x 25". Estate of Arshile Gorky

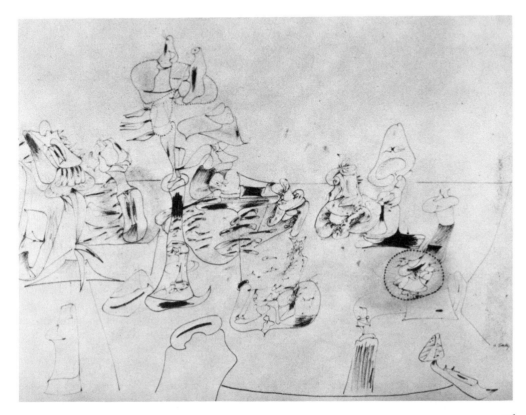

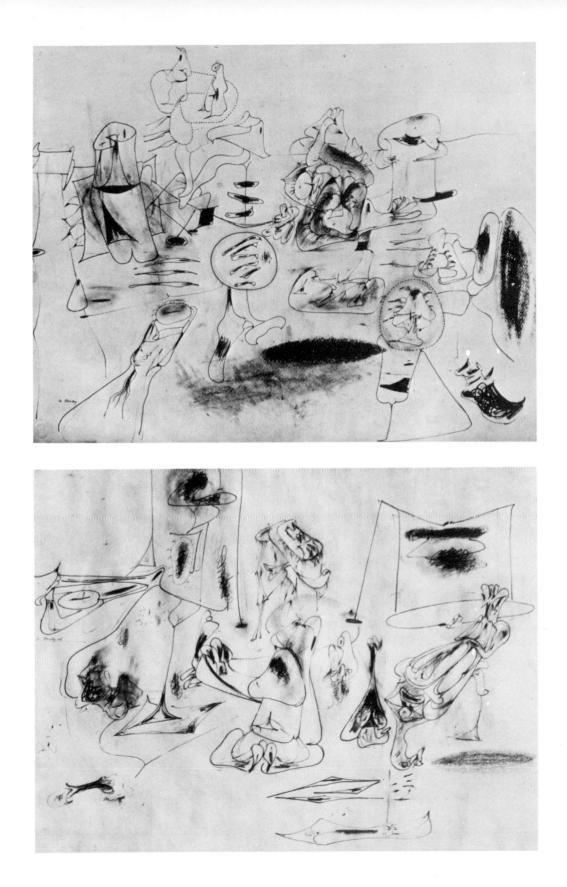

CHARRED BELOVED (1946)

In January, 1946, the barn in Sherman, Connecticut that Gorky used as a studio was destroyed by fire. "Paintings, drawings, sketches, and books, all were burned to ashes, not a thing was salvaged," Gorky wrote to his sister Vartoosh in February, adding: "Well, it's too great a loss for me, and I don't wish to write about it any longer, as I don't want you to worry about it too. We are well and I am still working" (bibl. 27, p. 114). At least twenty-seven paintings were lost, including some realistic portraits and flower paintings. *Charred Beloved I* and *II* were painted in New York shortly after the fire. Except for touches of red, they are painted entirely in black and gray, and the title can be thought of as commemorative.

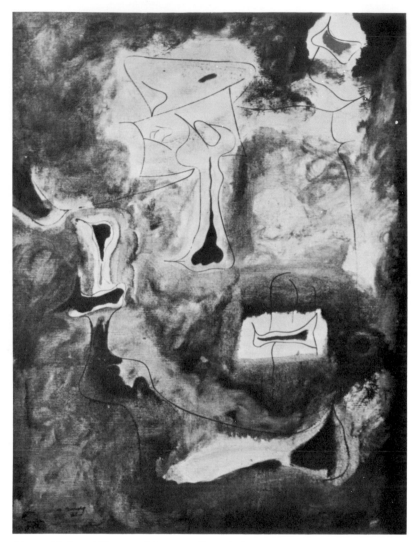

Charred Beloved II. 1946. Oil, 54 x 40". Michel Tapiés de Celéyran, Turin

Study for *Charred Beloved II.* (1946). Pencil on blue paper, 27 x 20". Estate of Arshile Gorky

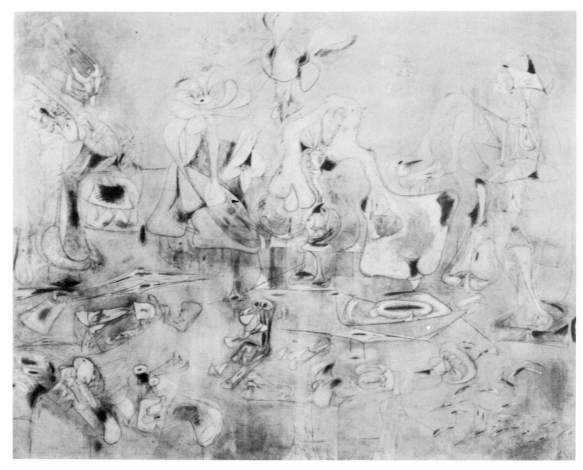

"Summation." (1947). Pencil, pastel, and oil on buff paper, 78⅜ x 100¼". Mr. and Mrs. Ben Heller, New York

''SUMMATION'' (1946)

This immense, many-faceted composition in line, tone and color exists also in several painstaking smaller studies. The title was added after Gorky's death, but nevertheless it is in a sense a summation of his work of 1946. "This is a world," Gorky told Ethel Schwabacher; she writes (bibl. 27, p. 120) of "a world dominated by the 'ghost of the unquiet father' inhabiting the person of André Breton, whose body was treated like an African or New Guinea fetish.... By the free use of double images

[Gorky] further emphasized the role of the secret progenitor (or father)." A father image is also evoked in *The Orators* (1947; destroyed by fire, 1961), in which a corpse is laid out full length with a candle at its feet. "Here, finally," Mrs. Schwabacher concludes (bibl. 27, p. 133), "the ghost of the unquiet father is laid with appropriate ceremony." Comparison with the full-size preparatory cartoons made for certain other canvases suggests that *"Summation"* may have been the final stage of what would have been Gorky's most ambitious painting in oil.

Study for *Agony*. Pencil and wax crayon, 22½ x 28⅝". Estate of Arshile Gorky

Study for *Agony*. Pencil, wax crayon, and gray wash, 22 x 30".
Estate of Arshile Gorky

AGONY (1947)

The succession of catastrophes that led to Gorky's suicide on July 21, 1948 began with the destruction of his paintings and his studio by fire in January, 1946 and his operation for cancer in February. During that year he underwent crushing blows to his physique, his personal life and his art. The tragic and beautiful canvas in The Museum of Modern Art is an outcome of these pressures. Compared with preparatory drawings, the anguished theme is aesthetically transformed; but the color scheme alone—cold yellow, smoldering and feverish reds, black patches in a curdled umber broth—justifies Gorky's title.

Unlike some other pictures of the period, *Agony* was not systematically developed from one master drawing, but was preceded by several bold studies spasmodically drawn with a soft black pencil. Each one, like the final painting, concentrates on the same structure—a fearful hybrid resembling a dentist's chair, an animated machine, a primitive feathered fetish or a human figure hanging on the rack, its rib cage hollow and its groin adorned with petals. The less shocking form it takes in the painting is studied in a few small wash drawings as an altered detail, and connected with an oval spot at the far left. *Agony* is not a landscape, but a furnished interior closed from behind by a partition; the floor line crosses the picture, and horizontal and vertical lines are echoed throughout. Silhouetted against the brightest cloud of red, at right center, a concave-sided plane is hung from a hook incised as sharply as a knife cut, and counterbalanced by a black weight. From the right a droll homunculus, his two huge vertebrae exposed, bows toward the center. It is of interest to note that a smaller version of the painting, done before the revision of the main motif and in a different color scheme, resembles a landscape. It is delicately painted in deft washes on a bare ground, and drawn with an almost lyrical lightness.

opposite above: *Agony*. 1947. Oil, 40 x 50½".
The Museum of Modern Art, New York. A. Conger Goodyear Fund

opposite left: Study for *Agony*. 1947. Oil, 36 x 48". Estate of Arshile Gorky

opposite right: Study for *Agony*. Ink and wash, 12¼ x 9⅜". Estate of Arshile Gorky

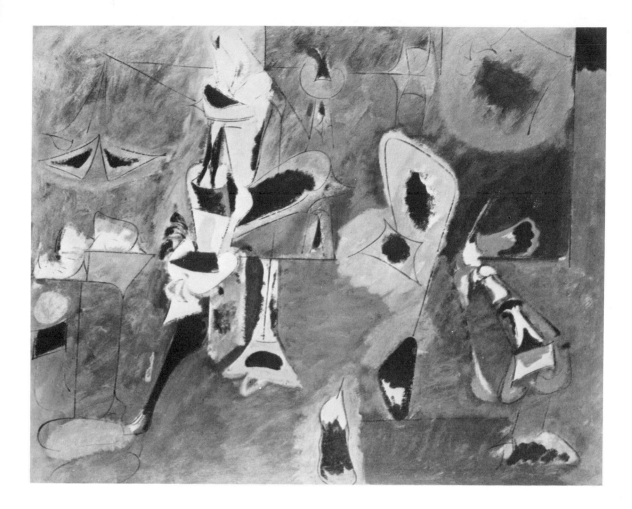

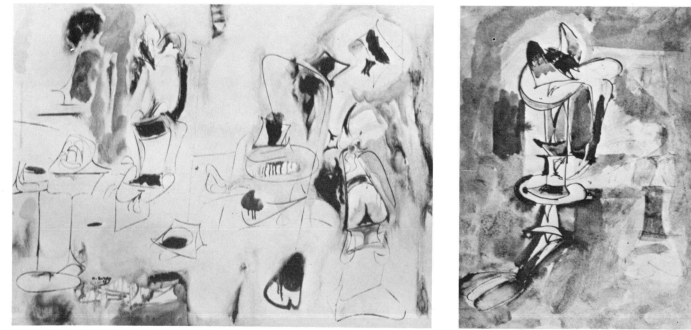

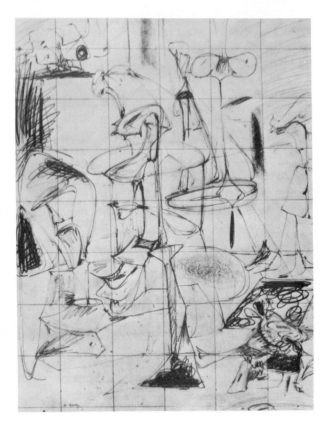

left: Study for *The Betrothal*. Pencil and wax crayon, 24 x 18¼". Estate of Arshile Gorky

below left: Study for *The Betrothal*. Pencil, charcoal, pastel and wax crayon, 49 x 39". Jeanne Reynal, New York

below: *The Betrothal I*. (1947). Oil, 50⅞ x 39⅞". Martha K. Jackson, New York

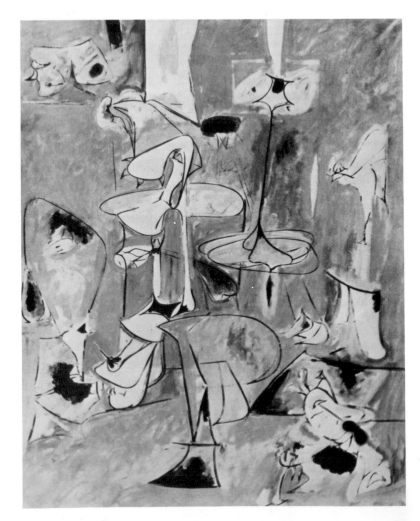

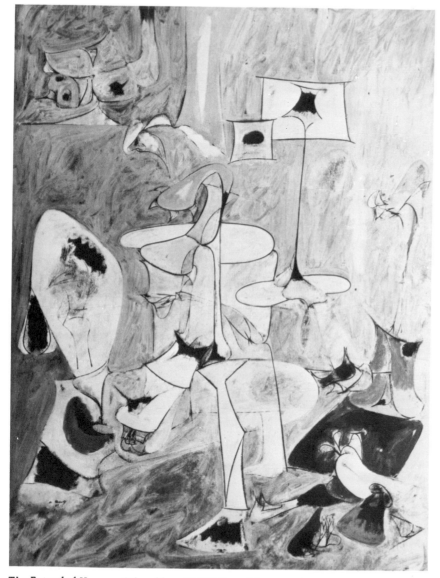

The Betrothal II. 1947. Oil, 50¾ x 38". Whitney Museum of American Art, New York

THE BETROTHAL (1947)

There are two paintings of *The Betrothal*, both derived from the same study, but one more finished than the other. The seemingly inscrutable elements of the composition, which simultaneously call to mind human figures, animals, plants and artifacts, are related to those of *Agony*, though their effect is regal and heraldic rather than tortured. From a clue given in a little sketch too delicate to reproduce, the complex of forms which fills the center and left foreground, surmounted by an erect figure with a four-pronged "head" (lilac against the sumptuous golden yellow background), can be identified as a quixotic rider astride a horse moving leftward; the horse's tail points toward the right and his head appears to be turned backward (though in the squared study it has a bearded human face). Gorky was fascinated by figures dressed in battle or parade costumes, and caparisoned horses. Several small paintings and drawings of horses exist, some attended by warriors carrying spears and shields. These works reflect ancient vase motifs and Uccello's battle groups.

Betrothal II is one of the most carefully completed of Gorky's paintings, and the black lines coincide most closely with the edges of painted shapes. If this superb picture has a flaw, it lies in being almost too beautiful and too finished. "I don't like that word, finish," Gorky told a Connecticut magazine reporter in 1948 (bibl. 7, p. 121): "When something is finished, that means it's dead, doesn't it? I believe in everlastingness. I never finish a painting—I just stop working on it for a while. I like painting because it's something I can never come to the end of. Sometimes I paint a picture, then I paint it all out. Sometimes I'm working on 15 or 20 pictures at the same time. I do that because I want to—because I like to change my mind so often. The thing to do is to always keep starting to paint, never finish painting."

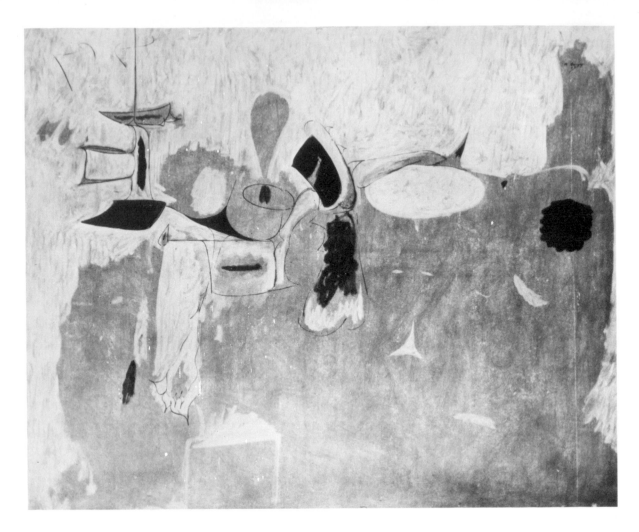

above: *The Limit.* (1947). Oil on paper, 50¾ x 62½".
Estate of Arshile Gorky

right: Study for *The Limit.* 1946. Pencil and wax
crayon, 19 x 25". Galleria Galatea, Turin

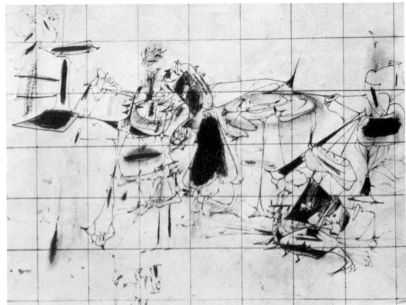

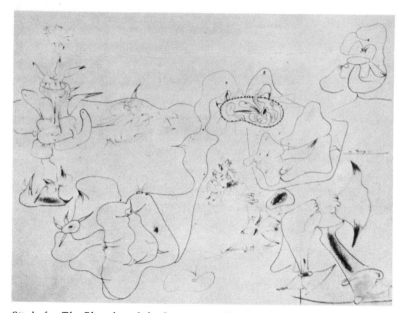

Study for *The Plough and the Song*. 1944. Pencil and wax crayon, 19 x 25¼". Allen Memorial Art Museum, Oberlin College

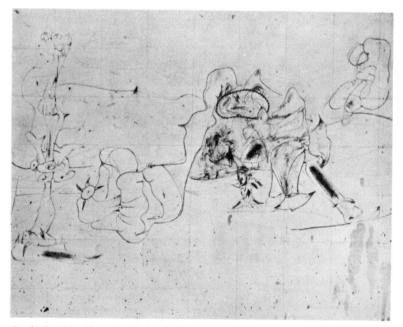

Study for *The Plough and the Song*. Pencil and wax crayon, 20 x 25". Mrs. Culver Orswell, Pomfret Center, Conn.

THE PLOUGH AND THE SONG (1944-47)

There were five completed paintings (counting two lost in the studio fire of 1946) in the "Plough-and-Song" series, and at least three drawings exist, including a full-sized cartoon touched with color (cat. 110). This ensemble is the clearest demonstration of Gorky's method, initiated during the thirties, of evolving several compositions from a single drawing. The three extant paintings are among his finest; their theme—the fertility of man and nature—underlies his entire life and work.

Gorky always yearned for the Caucasus in reminiscence or fantasy. Those who knew him well remember him singing Russian and Armenian songs at parties, in the fields or while preparing Armenian dishes; he was a friend of David Burliuk, who is known for paintings of large-visaged Russian peasants singing as they labor in the fields. As a schoolboy in Aikesdan, Gorky constantly carved and whittled, and while he was developing *The Plough and The Song* he made a small replica of an Armenian plough for his daughter Maro. It is constructed of delicately shaped wooden members held in position by tiny pegs and splines: its blade could be a pattern for the bonelike shapes, at once hard and soft, in Gorky's paintings.

Precise identification of details in *The Plough and The Song*, even as they appear in the first two studies, is impossible—Gorky masks personal meanings. But the tall construction at the left resembles the skeletal structures painted by Yves Tanguy; less firmly based, it disappears into an exotic "slipper" accented with violet crayon: one instance of the dangerously pointed shape which continually recurs after 1940.

The composition comprises four nuclei. That at the upper right suggests a nude female figure. One of the most curious is the prominent fleshy growth just right of the pointed slipper. It seems to separate into two parts, and provides the setting for a delicate four-petaled blossom, its center dotted with red. In the first drawing this entire polypoid mass projects forward, in an extreme perspective, far ahead of the left-hand column; but their rela-

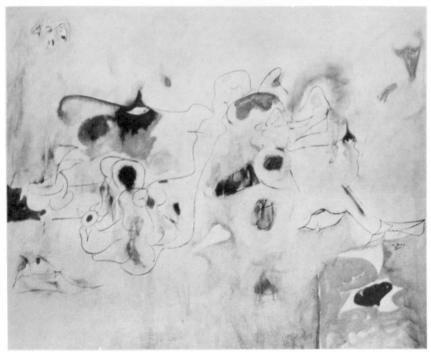

The Plough and the Song. 1947. Oil, 50¾ x 62¾".
Allen Memorial Art Museum, Oberlin College

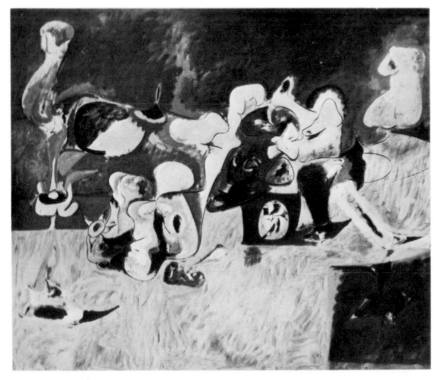

The Plough and the Song. (1947). Oil, 52 x 61½"
Mr. and Mrs. Stanley J. Wolf, Great Neck, New York

tionship is altered in the second drawing, which is restudied and flattened with the paintings already in mind. In both cases the perspective effect is heightened by the connecting tube which winds upward and enters a diagrammatically dotted ovary or womb within which are crowded forms resembling both human and floral anatomy. Below and at the right, diverse shapes form a bridge or receding cavern. The ringed central smudge in the second drawing seems to recede into the paper, and though the shapes at the right of it are bony and pelvic, they have the delicate softness of an iris, orchid or lily.

The second study for *The Plough and the Song* (like that for *The Artist and His Mother*, done in the thirties) was squared and enlarged, and in the full-size cartoon (cat. 110) color and value were studied in pastel and charcoal. The image was then transferred to canvas and (as in *The Liver Is the Cock's Comb*) many of the specific notes of yellow, red and blue were translated from crayon to pigment. The Oberlin canvas shows Gorky's method of beginning—and often finishing—in line and turpentine wash. At first it may have been only a way of starting, but friends—especially Matta, who also worked in line and thin paint—encouraged Gorky to stop, to preserve the first liquid freshness and continue on another canvas rather than bury successive revisions as he had earlier. Several of the original crayon hues, including the red center of the blossom at the left and the yellow and white "Fallopian tube," are carried into all three canvases. Yet they are strikingly different from each other because hue, value, tone modulation and surface quality always remained for Gorky subject to variation. Besides changing the appearance of similar areas from version to version, scraping and repainting enriched the color and paint quality by partially revealed earlier coats and, as in *The Artist and His Mother*, enabled Gorky to achieve the porcelainlike surface of his most finished work. By retaining chosen passages of an undercoat, moreover, entirely new forms were created.

Gorky's freedom was increased rather than hampered by adherence to a first statement. Its existence as one possible conclusion established a hypothetical progression from conception to realization that he could follow step by step, deviate from at any point, or abruptly abandon. Of the characteristic additions in the paintings, perhaps most important are the architectural subdivisions of space above and below the main image, areas often blank in the drawings: at the lower right, for example, suggestions from parts of the 1944 draw-

46

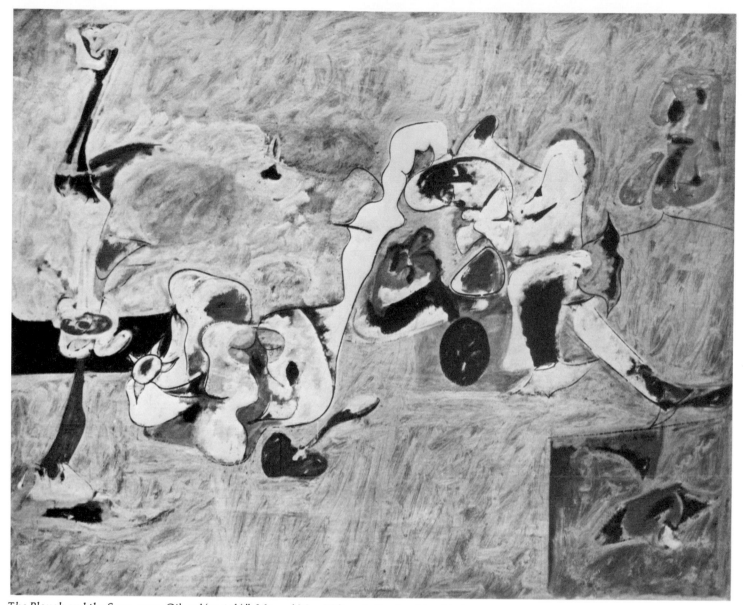

The Plough and the Song. 1947. Oil, 52⅛ x 64¼". Mr. and Mrs. Milton A. Gordon, New York

ing are combined in a new stabilizing motif, and the darkening of the band at the left, barely perceptible in the drawings, anchors the entire image to the picture frame.

By using his various and often contradictory means in concert, constantly falling upon new combinations of the lush colors which delighted him, and alternately obliterating the line image or reinforcing it, Gorky was a magician who could change foreground to background, model roundness and hollow depth, or compress bulk and re-

cession into the transparent picture plane that lies somewhere between the line scheme and the color scheme. Merely by the textural manipulation of a single background tone (using a device reflecting the brushwork of Cézanne and Miró) he could simultaneously create impressionist atmosphere, subdivide space into planes, and assert surface. These are magnificent paintings: their lyric beauty shows the exultant affirmation of universal creativity that Gorky distilled from the suffering of his last years.

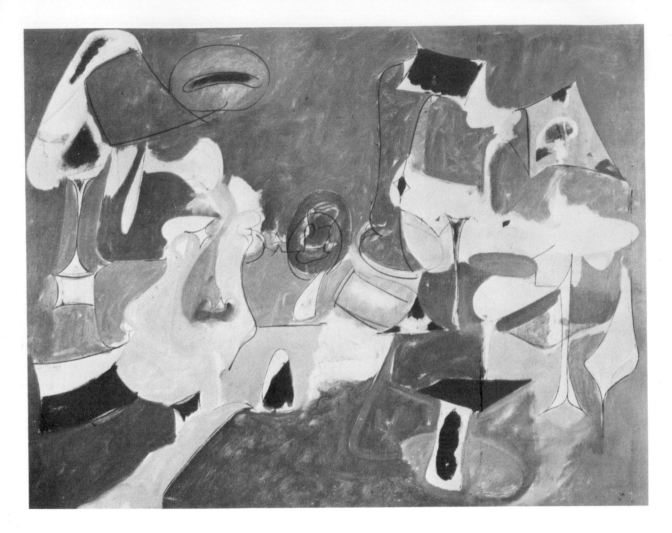

above: *Soft Night*. 1947. Oil, 38 x 50". Ruth Stephan,
Greenwich, Conn.

right: Study for *Soft Night*. 1946. Pencil and wax
crayon, 19½ x 24⅝". Estate of Arshile Gorky

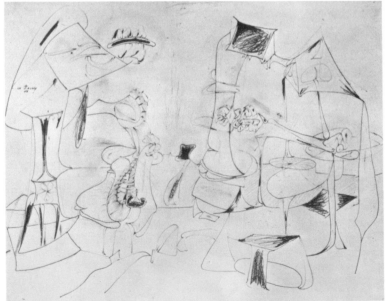

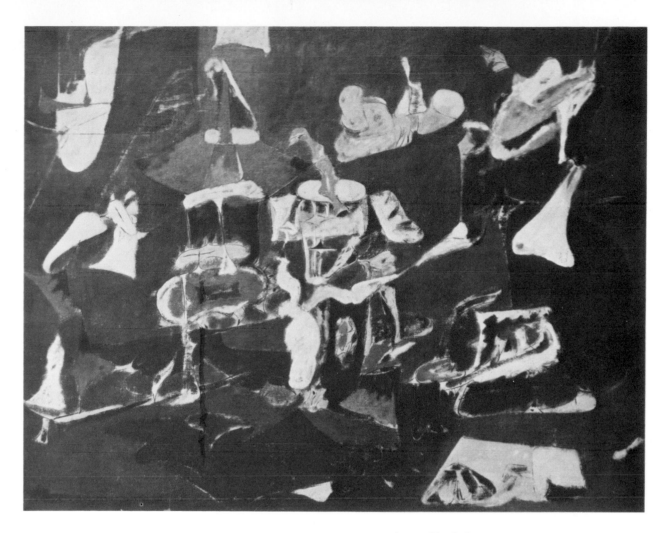

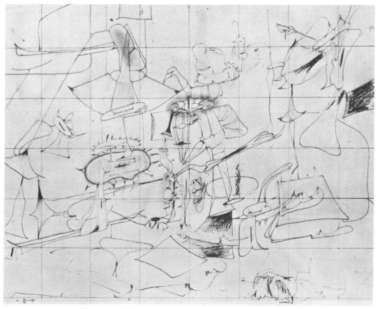

above: *"Dark Green Painting."* (c. 1948). Oil, 43⅞ x 55⅞". Mrs. H. Gates Lloyd, Haverford, Pa.

left: Study for *"Dark Green Painting."* 1946. Pencil and wax crayon, 19 x 24". Estate of Arshile Gorky

While Gorky was still painting, only a few outside the circle who knew him well realized how influential his art was to become; but during the fourteen years between his death and his retrospective exhibition at the Venice Biennial in 1962, his position in American and world art has been securely established. Gorky's career, as Meyer Schapiro wrote (bibl. 27, p. 11), "was remarkable as a development from what seemed a servile imitation of other painters to a high originality." For twenty years he strove to make qualities he admired in other artists—from the geometry of Uccello to the fluidity and open form of Kandinsky and Matta—his own. As a result, Gorky was one of the first American artists intentionally to bring together contradictory styles, ideas and principles. His own final style was both an innovation and a synthesis.

Although he was far from fully recognized while he lived, Gorky was a leader even before his first major one-man show in 1945, when he stood at the threshold of what was later called "the new American painting." The "look" of New York painting of the fifties was bounded on the one hand by 1911 cubism and the early work of Mondrian, and on the other by expressionist brushwork. Neither characteristic can be found in Gorky's late painting. He was an "abstract surrealist" if you will, but was never an abstract expressionist or an "action painter," although in 1947, in such pictures as "*Dark Green Painting*," he was moving toward a more heavily pigmented and closely packed spotting of the canvas. Because he was forced to discover his own tradition Gorky developed slowly, and he ended his life just five years after his full originality had coalesced. Hypothetical though the question is, it is hard not to wonder how this intellectual, endowed and passionate artist would have continued to develop had he lived as long as the renowned painters of the twentieth century he so greatly admired.

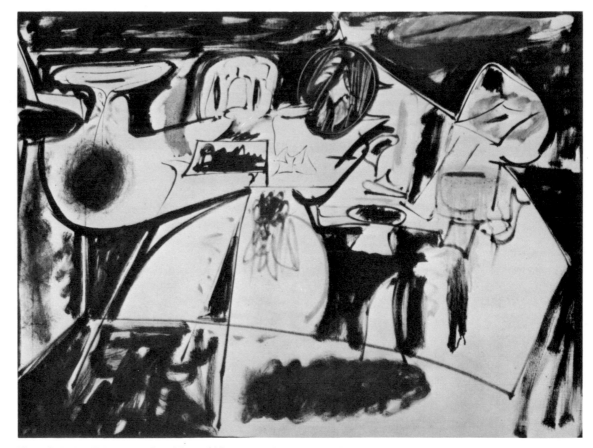

"*Last Painting.*" (1948). Oil, 30¾ x 39¾". Estate of Arshile Gorky

Brief Chronology

1904 Gorky (Vosdanig Manoog Adoian) born in Khorkom Vari Haiyotz Dzor, a village in Armenia; father a wheat farmer and trader.

1914 June 15: After massacre of Armenians by the Turks, family moves to city of Erevan.

1920 March 1: Arrives at Ellis Island with his younger sister, Vartoosh. Lives in Boston, Providence and Watertown, Mass. Takes classes at Rhode Island School of Design, Providence Technical High School and New School of Design, Boston.

c. 1925 Changes name to "Arshele," and later "Arshile" Gorky. Moves to New York City, taking a studio on Sullivan Street. Studies and teaches at Grand Central School, where he stays until 1931.

1929 Begins friendship with Stuart Davis.

1930 April 11-27: Shows 3 still-life paintings in Museum of Modern Art exhibition, *46 Painters and Sculptors under 35 Years of Age*.

1932 Invited to join "Abstraction, Création, Art Non-Figuratif" group in Paris.

c. 1933 Begins friendship with Willem de Kooning.

1934 First one-man show at Mellon Galleries, Philadelphia. End of association with Davis.

1935 Joins WPA Federal Art Project: begins a mural, *Aviation: Evolution of Forms under Aerodynamic Limitations*, for Newark Airport (present location unknown). First marriage, to Marny George; divorced soon after.

1936 First magazine article on Gorky, by Frederick Kiesler, (bibl. 20).

1937 First museum purchase: Whitney Museum of American Art, *Painting*, 1936-37 (shown in Musée du Jeu de Paume, Paris, 1938 by Museum of Modern Art).

1938 First one-man show of paintings in New York, at Boyer Galleries.

1939 Murals for the Aviation Building at New York World's Fair (present location unknown).

1941 Course in Camouflage organized at the Grand Central School of Art. Murals for Ben Marden's Riviera, Fort Lee, N. J. The Museum of Modern Art acquires two works by gift. Retrospective exhibition of twenty paintings at the San Francisco Museum of Art. September 15: Second marriage, to Agnes Magruder, in Virginia City, Nevada.

1942 Summer: Visit to Saul Schary's home in Connecticut initiates last period of his art. The Museum of Modern Art acquires *Garden in Sochi* by cash and exchange.

1943 Summer: First of a series of visits to Crooked Run Farm, Hamilton, Virginia, owned by Agnes Gorky's parents, during which Gorky draws out-of-doors.

1944 Meets André Breton and surrealist artists.

1945 Exhibits at Julien Levy Gallery, New York and shows there annually through 1948.

1946 January: About twenty-seven of his paintings destroyed by fire in his studio at Sherman, Connecticut. February: Operated on for cancer. During the summer and fall about 300 drawings done in Virginia. Represented by 8 paintings and 2 drawings in the exhibition, *Fourteen Americans*, at the Museum of Modern Art.

1947 Settles permanently in Sherman, Connecticut.

1948 June 26: Neck broken and painting arm injured in automobile accident. July 21: Commits suicide by hanging in Sherman.

Selected References

Owing to continuously cumulated data, including exhibitions, published comprehensively in 1951 (bibl. 28), 1957 (bibl. 27), 1961 (bibl. 22, 26) and 1962 (bibl. 19), it is possible to restrict this bibliography to supplemental material in the Museum Library and to citations considered of prime relevance on the present occasion. BERNARD KARPEL

1 ARTI VISIVE. No. 6-7, Summer 1957.
 "Numero dedicato a Arshile Gorky", with texts from Schwabacher, numerous illustrations, and bilingual essay by Toti Scialoja.

2 APOLLONIO, UMBRO. Arshile Gorky. *In* Venice. Biennial. XXXI Biennale Internazionale d'Arte. p. 111-113 ill. Venice, 1962.
 Lists 43 works, p. 113-114 (4 ill.). Article by R. Barilli, *La Biennale di Venezia*, no. 43 (1962).

3 ASHTON, DORE. Arshile Gorky, peintre romantique. *XX^e Siècle* no. 19, p. 76-80 ill. June 1962.
 Also original English text, p. [127] ff.

4 BARR, ALFRED H., Jr. Gorky, De Kooning, Pollock. *Art News* 49 no. 4, p. 22, 60 ill. June-Aug. 1950.
 From catalogue of the XXV Biennale, Venice.

5 BARR, ALFRED H., Jr. Introduction. *In* The New American Painting. p. 15-19. New York, Museum of Modern Art (distributed by Doubleday), 1959.
 "As shown in eight European countries 1958-1959, organized by the International Program". Gorky, p. 32-35 (ill.), with text by Breton and De Kooning. Other relevant museum catalogues: 46 Painters and Sculptors under 35 Years of Age (1930).—New Horizons in American Art (1936). —Trois Siècles d'Art aux Etats-Unis (1938).— Fourteen Americans (1946).—Abstract Painting and Sculpture in America (1951).

6 BRETON, ANDRÉ. Arshile Gorky. *In* Le Surréalisme et la peinture. p. 196-199. New York, Brentano, 1945.
 Translated by Julien Levy as introduction for his Gorky exhibition catalogue, Mar. 1945. Extracts also published in *Fourteen Americans* and *The New American Painting* (bibl. 5). Note bibl. 23.

7 CLAPP, TALCOTT B. A painter in a glass house. *Sunday Republican Magazine (Waterbury, Conn.)* Feb. 9, 1948.

8 DAVIS, STUART. Arshile Gorky in the 1930's: a personal recollection. *Magazine of Art* v. 44, p. 56-58 Feb. 1951.
 Introduction by James T. Soby. "Notes on eight works" by Lloyd Goodrich, p. 59-61 (ill.).

9 DE KOONING, ELAINE. Gorky, painter of his own legend. *Art News* v. 49, p. 38-41, 63-66 ill. Jan. 1951.

10 GOLDWATER, ROBERT. Reflections on the New York school. *Quadrum* no. 8, p. 17-36 ill. 1960.

11 GOODRICH, LLOYD. Arshile Gorky. *In* New Art in America, ed. by John I. H. Baur. p. 188-191 ill. Greenwich, Conn., New York Graphic Society, 1957.
 Complemented by critical annotations (bibl. 8) and extensive biographical note (bibl. 28).

12 GORKY, ARSHILE. Stuart Davis. *Creative Art* v. 9, p. 213, 217 Sept. 1931.
 Davis asserts article not written in this form.

13 GOTTLIEB, ADOLPH. [Preface] *In* Kootz Gallery. Ar-

shile Gorky. New York, Mar. 28-Apr. 24, 1950.

14 GREENBERG, CLEMENT. Art [a weekly commentary]. *The Nation* 1945-1948.
 See Mar. 24, 1945 (p. 342-4).—May 4, 1946 (p. 552-3).—Jan. 10 (p. 42), Mar. 20 (p. 331-2), Dec. 11, 1948 (p. 676).

15 GREENBERG, CLEMENT. "American type" painting. *Partisan Review* v. 22, no. 2, p. 179-196 Spring 1955.
 Additional commentary: The decline of cubism (Mar. 1948).—Two reconsiderations (May-June 1950).—Also: New York painting only yesterday (*Art News*, June 1957).

16 GUILD ART GALLERY: [a review]. *New York Times* Oct. 13, 1935.

17 HESS, THOMAS B. Abstract Painting: Background and American Phase. p. 5, 105-106, 180-111 ill. New York, Viking, 1951.

18 JANIS, SIDNEY. Abstract and Surrealist Art in America. p. 120 ill. New York, Reynal & Hitchcock, 1944.

19 JOUFFROY, ALAIN. Arshile Gorky et les secrets de la nuit. *Cahiers du Musée de Poche* no. 2, p. 75-85 ill. June 1959.

20 KIESLER, FREDERICK J. Murals without walls, relating to Gorky's Newark project. *Art Front* v. 2, no. 11, p. 10-11 ill. Dec. 18, 1936.

21 MOORADIAN, KARLEN. Arshile Gorky. *Armenian Review (Boston)* v. 8, no. 2, p. 49-58 ill. June 1955.

22 REIFF, ROBERT F. A stylistic analysis of Gorky's art from 1943-1948. 277 p. ill. New York, 1961.
 Bibliography, p. 265-275. Columbia University dissertation available at University Microfilm, Ann Arbor, Mich. (M I C 61—2222).

23 ROSENBERG, HAROLD. Arshile Gorky: the Man, the Time, the Idea. 144 p. ill. New York, *Horizon*, 1962.
 Bibliography, p. 138-143. Translates Breton's "Farewell to Arshile Gorky." Biographical excerpts published in *Portfolio & Art News Annual* no. 5, p. 102-114 ill. 1962.

24 SCHAPIRO, MEYER. Gorky: the creative influence. *Art News* v. 56, no. 5, p. 28-31, 52 ill. Sept. 1957.

25 SEITZ, WILLIAM. Spirit, time and "abstract expressionism". *Magazine of Art* v. 46, p. 82-84 ill. Feb. 1953.
 Also: Arshile Gorky's 'The Plough and the Song'. *Allen Memorial Art Museum Bulletin* v. 12, p. 4-15 ill. Fall 1954.

26 SOLOMON R. GUGGENHEIM MUSEUM. American Abstract Expressionists and Imagists. New York, 1961.
 Bibliography, p. 108-109.

27 SCHWABACHER, ETHEL K. Arshile Gorky. 159 p. ill. New York, Published for the Whitney Museum by Macmillan Co., 1957.
 Preface by Lloyd Goodrich; introduction by Meyer Schapiro. Bibliography p. 153-155. This extensive documentation is now deposited in the Whitney Museum of American Art.

28 WHITNEY MUSEUM OF AMERICAN ART. Arshile Gorky: Memorial Exhibition. 50 p. ill. New York, 1951.
 Also shown at Minneapolis and San Francisco. Text by E. K. Schwabacher, p. 7-41. Chronology, biography, exhibitions noted by L. Goodrich, p. 42-44.

Catalogue

Titles in quotation marks were not given by the artist. Paintings and drawings are listed together; chronology is interrupted when necessary to group related works. Dates enclosed in parentheses do not appear on the works. It should be noted that certain of the portraits are wrongly dated, and that the dates of certain other works (especially of the thirties) have not yet been precisely determined. In dimensions height precedes width. Works marked with an asterisk are illustrated.

1 *Beach Scene.* (c. 1925). Oil on canvas, 18½ x 22". Collection Mr. and Mrs. Merlin Carlock, New York

* 2 *Park Street Church, Boston.* (c. 1925). Oil on canvas board, 16 x 12". Signed lower right: "Gorky/ Arshele." Collection Mrs. Edward M. Murphy, Lowell, Mass. Ill. p. 10

* 3 *Still Life.* (c. 1927). Oil on canvas, 20 x 24". Estate of Arshile Gorky. Ill. p. 11

* 4 *Landscape, Staten Island.* (1927-28). Oil on canvas, 32 x 34". Collection Mr. and Mrs. Hans Burkhardt, Los Angeles. Ill. p. 11

5 *Landscape.* (c. 1928?). Pencil, 12¼ x 19". Estate of Arshile Gorky

* 6 *Composition.* (c. 1928). Oil on canvas, 43 x 33". Collection Mr. and Mrs. I. Donald Grossman, New York. Ill. p. 12

* 7 *Still Life.* 1929. Oil on canvas, 36⅛ x 48⅛". Signed and dated upper left. Collection Jeanne Reynal, New York. Ill. p. 13

FIGURE PAINTINGS AND DRAWINGS

8 *Portrait of Myself and My Imaginary Wife.* (1923?). Oil on cardboard, 9 x 14". Signed and dated upper left: "A Gorky/23." The Joseph H. Hirshhorn Collection

9 *Lady in Red Dress.* (c. 1931). Oil on canvas, 10 x 8⅛". Signed and dated lower left: "A Gorky/ XXII." The Joseph H. Hirshhorn Collection

*10 *Portrait of Vartoosh.* (c. 1933). Oil on canvas, 20⅛ x 15". Signed and dated lower left: "A Gorky/XXII." The Joseph H. Hirshhorn Collection. Ill. p. 14

11 *Three pencil drawings.* (c. 1933): 9⅞ x 8½"; 8¾ x 5⅝"; 8⅞ x 5⅛". Collection Ethel K. Schwabacher, New York

*12 *Self Portrait.* (c. 1933). Oil on canvas, 10 x 8". Collection Rebecca and Raphael Soyer, New York. Ill. p. 14

*13 *Self Portrait.* (c. 1935). Pencil, 9⅞ x 8¼". Collection Ethel K. Schwabacher, New York. Ill. p. 14

*14 *Self Portrait.* (c. 1937). Oil on canvas, 55½ x 34". Estate of Arshile Gorky. Ill. p. 15

*15 *The Artist and His Mother.* Two studies: Ink, 8½ x 11". Estate of Arshile Gorky. Ill. p. 17

*16 *The Artist and His Mother.* Pencil on squared paper, 24 x 19". Estate of Arshile Gorky. Ill. p. 17

*17 *The Artist and His Mother.* (c. 1926-36). Oil on canvas, 60 x 50". Estate of Arshile Gorky. Ill. p. 18

*18 *The Artist and His Mother.* (c. 1926-36). Oil on canvas, 60 x 50". Signed and dated lower right: "A Gorky/26-9." Whitney Museum of American Art, New York. Gift of Julien Levy for Maro and Natasha Gorky in memory of their father. Ill. p. 19

*19 *Portrait of Master Bill.* (c. 1937). Oil on canvas, 52 x 40⅛". Estate of Arshile Gorky. Ill. p. 16

NIGHTTIME, ENIGMA AND NOSTALGIA

*20 *Drawing.* (c. 1931-32). Pencil, 22½ x 29". Martha Jackson Gallery, New York, Ill. p. 20

*21 *Drawing.* (c. 1931-32). Black and brown ink, 21⅝ x 28". Collection Ethel K. Schwabacher, New York. Ill. p. 20

*22 *Drawing.* (c. 1931-32). India ink, 12¾ x 21¾". Signed top right of center. Collection Mr. and Mrs. Philip Gersh, Beverly Hills, Calif. Ill. p. 20

*23 *Nighttime, Enigma and Nostalgia.* (c. 1934). Oil on canvas, 36 x 48". Martha Jackson Gallery, New York. Ill. p. 21

24 *Organization.* (c. 1934). Oil on canvas, 14⅛ x 22". Signed lower right. University of Arizona Art Gallery, Tucson. Edward Joseph Gallagher III Memorial Collection

25 *Drawing.* (c. 1931-32). Ink, 24 x 31". Rose Fried Gallery, New York

*26 *Drawing.* (c. 1931-32). Ink, 22 x 30". Signed lower right. Estate of Arshile Gorky. Ill. p. 21

*27 *Organization.* (c. 1934-36). Oil on canvas, 49¾ x 60". Estate of Arshile Gorky. Ill. p. 23

*28 *Composition with Head.* (c. 1934-36). Oil on canvas, 78 x 62". Estate of Arshile Gorky. Ill. p. 22

29 *Untitled.* (c. 1936). Oil on canvas, 30¼ x 11⅛". Margit Chanin, Ltd., New York

*30 *Study for Xhorkom.* Pencil, 19 x 25". Estate of Arshile Gorky. Ill. p. 24

*31 *Xhorkom.* (c. 1936). Oil on canvas, 40 x 52". Estate of Arshile Gorky. Ill. p. 24

*32 *Image in Xhorkom.* (c. 1936). Oil on canvas, 32⅞ x 43". Collection Jeanne Reynal, New York. Ill. p. 24

33 *Untitled.* 1936. Oil on canvas, 24⅛ x 34⅛". Signed and dated center right. Collection Mr. and Mrs. Abraham L. Chanin, New York

34 *Enigmatic Combat.* (c. 1936). Oil on canvas, 35¾ x 48". San Francisco Museum of Art. Gift of Miss Jeanne Reynal

*35 *Study for Painting.* (c. 1932). Black and brown ink, 10 x 15". Collection Mr. and Mrs. Hans Burkhardt, Los Angeles. Ill. p. 25

*36 *Painting.* (1936-37). Oil on canvas, 38 x 48". Signed upper right. Whitney Museum of American Art, New York. Ill. p. 25

*37 *Composition.* (1936-37; a variant of Cat. 36). Oil on canvas, 36 x 48". Collection Mr. and Mrs. I. Donald Grossman, New York. Ill. p. 25

38 *Gray Painting.* (c. 1937). Oil on canvas, 29 x 40". Signed lower right. Estate of Arshile Gorky

39 *Still Life with Flowers.* (c. 1938). Oil on canvas, 34 x 26". Signed lower left. Collection Mrs. Moorad Mooradian, Chicago

*40 *Garden in Sochi.* Oil on canvas, 25 x 29". Signed lower left of center. Estate of Arshile Gorky. Ill. p. 26.

41 *Painting.* Oil on canvas, 23 x 30". Signed upper left. Estate of Arshile Gorky

*42 *Garden in Sochi.* Oil on canvas, 31 x 39". Signed lower right. Estate of Arshile Gorky. Ill. p 26

43 *Composition.* Oil on canvas, 18⅛ x 20". Collection Jeanne Reynal, New York

*44 *Garden in Sochi.* (1941). Oil on canvas, 44¼ x 62¼". The Museum of Modern Art, New York. Purchase Fund and gift of Wolfgang S. Schwabacher (by exchange). Ill. p. 27

*45 *The Pirate I.* 1942. Oil on canvas, 29¼ x 40⅛". Signed and dated center left. Collection Mr. and Mrs. Julien Levy, Bridgewater, Conn. Ill. p. 28

*46 *The Pirate II.* 1943. Oil on canvas, 30 x 36". Signed and dated upper right. Collection Mr. and Mrs. Julien Levy, Bridgewater, Conn. Ill. p. 28

47 *Waterfall.* (c. 1943). Oil on canvas, 60½ x 44½". Estate of Arshile Gorky

*48 *Housatonic Falls.* (begun 1942-43). Oil on canvas, 34 x 44". Collection Mr. and Mrs. William B. Jaffe, New York. Ill. p. 50

49 *"Golden Brown Painting."* (similar to cat. 48; begun 1942-43, probably finished later). Oil on canvas, 43½ x 56". Washington University, St. Louis.

50 *Composition I.* (1943). Pencil, ink, and wax crayon, 19 x 24⅞". Collection Ann Dunnigan, New York

51 *Drawing.* (c. 1943). Pencil and wax crayon, 19¾" 26¾". Collection Mr. and Mrs. Gaston de Havenon, New York

*52 *Drawing.* 1943. Pencil and wax crayon, 20 x 26¾". Signed and dated lower left. Collection Mrs. David Metzger, New York. Ill. p. 29

53 *Virginia Landscape.* (1943). Pencil and wax crayon, 20 x 27". Collection Mrs. Albert H. Newman, Chicago

*54 *Virginia Landscape.* (1943). Pencil and wax crayon, 20 x 27". Signed center right. Collection Mr. and Mrs. Stephen D. Paine, Boston. Ill. p. 29

*55 *Drawing.* 1943. Pencil and wax crayon, 18½ x 23½". Signed and dated lower right. Collection Mr. and Mrs. Stephen Hahn, New York. Ill. p. 29

*56 *Anatomical Blackboard.* 1943. Pencil and wax crayon, 20¼ x 27⅜". Signed and dated upper left. Collection Mr. and Mrs. Walter Bareiss. Ill. p. 30

*57 *Landscape.* 1943. Pencil and wax crayon, 20¼ x 27⅜". Signed and dated upper left. Collection Mr. and Mrs. Walter Bareiss. Ill. p. 30

58 *Drawing.* (1943). Pencil and wax crayon, 21⅞ x 29¾". Collection Mr. and Mrs. Joseph H. Hazen, New York

59 *Flower Study.* (c. 1944). Oil on canvas, 19½ x 15½". Collection Mr. and Mrs. Gaston de Havenon, New York

60 *Untitled.* 1944. Oil on canvas, 30 x 37¾". Signed and dated center left. Collection Mr. and Mrs. Stephen D. Paine, Boston

*61 *How My Mother's Embroidered Apron Unfolds in My Life.* (1944). Oil on canvas, 40 x 45". Signed center left. Collection Mr. and Mrs. C. Bagley Wright, Jr., Seattle. Ill. p. 32

*62 *The Leaf of the Artichoke is an Owl.* 1944. Oil on canvas, 28 x 36". Signed and dated center left. Collection Ethel K. Schwabacher, New York. Ill. p. 32

*63 *Water of the Flowery Mill.* 1944. Oil on canvas, 42 x 48¾". Signed and dated upper left. The Metropolitan Museum of Art, George A. Hearn Fund, 1956. Ill. p. 31

64 *Drawing.* (c. 1944). Pencil and wax crayon, 19½ x 25⅛". Signed lower right of center. Estate of Arshile Gorky

*65 Study for *Good Afternoon, Mrs. Lincoln.* 1944. Pencil and wax crayon, 20 x 26". Signed and dated lower right. Collection Mr. and Mrs. Julien Levy, Bridgewater, Conn. Ill. p. 33

66 *Good Afternoon, Mrs. Lincoln.* 1944. Oil on canvas, 30 x 38". Signed and dated lower left. Estate of Arshile Gorky. Ill. p.

*67 Study for *The Liver Is the Cock's Comb.* 1943. Pencil, ink, and wax crayon on buff paper, 18½ x 47½". Signed and dated lower right. Collection Mr. and Mrs. Frederick R. Weisman, Beverly Hills, Calif. Ill. between pp. 32-33

*68 *The Liver Is the Cock's Comb.* 1944. Oil on canvas, 73 x 98½". Signed and dated upper left. Albright-Knox Art Gallery, Buffalo, New York. Gift of Seymour H. Knox. Ill. between pp. 32-33

69 *The Sun, the Dervish in the Tree.* 1944. Oil on canvas, 35¾ x 47". Signed and dated upper right. Collection Joshua Binion Cahn, New York

70 *They Will Take My Island.* (1944). Oil on canvas, 38 x 48". Collection Jeanne Reynal, New York

71 *Drawing.* (1944-45). Pencil and wax crayon, 18 x 24". Signed lower right. Estate of Arshile Gorky

72 *Drawing.* (c. 1945). Pencil and wax crayon, 19 x 25". Estate of Arshile Gorky

*73 *The Diary of a Seducer.* 1945. Oil on canvas, 50 x 62". Signed and dated lower left. Collection Mr. and Mrs. William A. M. Burden, New York. Ill. p. 2

*74 *Impatience.* 1945. Oil on canvas, 24 x 36". Signed and dated lower right of center. Collection Dr. and Mrs. Israel Rosen, Baltimore. Ill. p. 35

*75 *Landscape Table.* 1945. Oil on canvas, 36 x 48". Signed and dated lower left. Collection Mr. and Mrs. B. H. Friedman, New York. Ill. p. 35

76 *Pastoral.* 1945. Oil on canvas, 25½ x 32½". Signed and dated lower left. Collection Mr. and Mrs. Julien Levy, Bridgewater, Conn.

77 *Child's Companions.* 1945. Oil on canvas, 34⅛ x 46⅛". Signed and dated lower left. Collection Mr. and Mrs. Julien Levy, Bridgewater, Conn.

*78 Study for *The Unattainable.* (1945). Pencil and wax crayon, 24 x 18". Estate of Arshile Gorky. Ill. p. 34

*79 *The Unattainable.* 1945. Oil on canvas, 41¼ x 29¼". Signed and dated lower right. Collection Barney Rosset, New York. Ill. p. 34

*80 *Pink Drawing.* (1946). Pencil and wax crayon, 19 x 25". Signed lower right. Estate of Arshile Gorky. Ill. p. 36

*81 *Drawing.* (1946). Pencil and wax crayon, 19 x 25". Signed lower left. Collection Mrs. Herbert Ferber, New York. Ill. p. 37

82 Study for *From a High Place II.* 1946. Pencil and

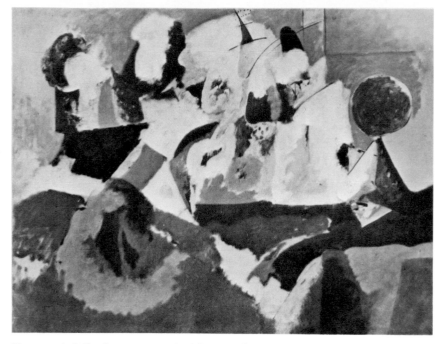

Housatonic Falls. (begun 1942-43). Oil, 34 x 44". Mr. and Mrs. William B. Jaffe, New York

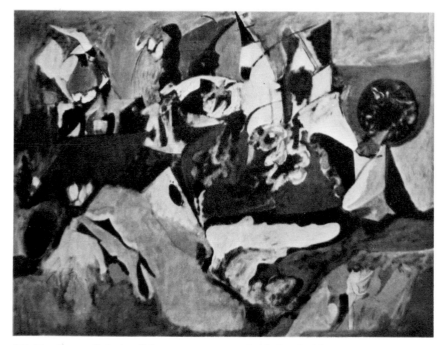

"Golden Brown Painting." (begun 1942-43; probably finished later). Oil, 43½ x 56". Washington University, St. Louis

wax crayon on buff paper, 13⅛ x 20¼". Signed and dated upper left. Estate of Arshile Gorky

83 *From a High Place II.* (1946). Oil on canvas, 17 x 24". Estate of Arshile Gorky

*84 Study for *Charred Beloved II.* (1946). Pencil on blue paper, 27 x 20". Estate of Arshile Gorky. Ill. p. 38

*85 *Charred Beloved II.* 1946. Oil on canvas, 54 x 40". Signed and dated lower left. Collection Michel Tapiés de Celéyran, Turin. Ill. p. 38

86 *Nude.* 1946. Oil on canvas, 50 x 38⅛". Signed and dated lower right. Collection Mr. and Mrs. Fredric Várady, New York

87 Drawing from *The Pirate.* 1946. Pencil, 18¾ x 24½". Signed and dated lower right of center. Collection Mr. and Mrs. Julien Levy, Bridgewater, Conn.

88 Drawing. 1946. Pencil and wax crayon on gray paper, 19⅛ x 24⅞". Signed and dated lower left. Collection Mr. and Mrs. Julien Levy, Bridgewater, Conn.

89 Drawing. 1946. Pencil and wax crayon, 18⅜ x 24½". Signed and dated lower left. Collection Mr. and Mrs. Julien Levy, Bridgewater, Conn.

*90 Drawing. 1946. Pencil and wax crayon, 22 x 30". Signed and dated lower right. Estate of Arshile Gorky. Ill. p. 36

"SUMMATION" (1946-47)

91 Drawing. 1946. Pencil and wax crayon, 19 x 24". Signed and dated lower right. Sidney Janis Gallery, New York

92 Drawing. 1946. Pencil and wax crayon, 18½ x 24½". Signed and dated lower right of center. Whitney Museum of American Art, New York. Gift of Mr. and Mrs. Wolfgang S. Schwabacher

*93 "Summation." (1947). Pencil, pastel, and oil on buff paper, on composition board, 78⅜ x 100¼". Collection Mr. and Mrs. Ben Heller, New York. (Exhibited in New York only). Ill. p. 39

94 *Making the Calendar.* 1947. Oil on canvas, 34 x 41". Signed and dated left above center. Munson-Williams-Proctor Institute, Utica, New York

95 "Portrait of the Artist's Wife." (c. 1947). Oil on canvas, 31 x 22". Signed upper right. Collection Dr. and Mrs. David Abrahamsen, New York

AGONY (1946-47)

*96 Study I. Pencil and wax crayon, 22½ x 28⅝". Signed lower right. Estate of Arshile Gorky. Ill. p. 40

97 Study II. Pencil and wax crayon, 19 x 25". Signed lower right. Estate of Arshile Gorky

*98 Study. Ink and wash, 12¼ x 9⅜". Estate of Arshile Gorky. Ill. p. 41

*99 Study. Pencil, wax crayon, and gray wash, 22 x 30". Signed lower right of center. Estate of Arshile Gorky. Ill. p. 40

*100 Study. 1947. Oil on canvas, 36 x 48". Signed and dated lower left. Estate of Arshile Gorky. Ill. p. 41

*101 *Agony.* 1947. Oil on canvas, 40 x 50½". Signed and dated side left. The Museum of Modern Art, New York. A. Conger Goodyear Fund. Ill. p. 41

THE BETROTHAL (1946-47)

*102 Study. Pencil and wax crayon, 24 x 18¼". Signed lower left. Estate of Arshile Gorky. Ill. p. 42

*103 Study. Pencil, charcoal, pastel and wax crayon, 49 x 39". Collection Jeanne Reynal, New York. Ill. p. 42

104 Study. Watercolor and pencil, 24 x 18". Collection Mr. and Mrs. Harris B. Steinberg, New York

*105 *The Betrothal I.* (1947). Oil on canvas, on composition board, 50⅞ x 39⅞". Collection Martha K. Jackson, New York. Ill. p. 42

*106 *The Betrothal II.* 1947. Oil on canvas, 50¾ x 38". Signed and dated lower left. Whitney Museum of American Art, New York. Ill. p. 43

*107 Study for *The Limit.* 1946. Pencil and wax crayon, 19 x 25". Signed and dated lower left. Galleria Galatea, Turin. Ill. p. 44

*108 *The Limit.* 1947. Oil on paper over burlap, 50¾ x 62½". Signed and dated upper right. Estate of Arshile Gorky. Ill. p. 44

THE PLOUGH AND THE SONG (1944-47)

*109 Study. 1944. Pencil and wax crayon, 19 x 25¼". Signed and dated center right. Allen Memorial Art Museum, Oberlin College, Oberlin, Ohio. Ill. p. 45

110 Study. (1946). Pencil, charcoal, wax crayon, pastel and oil, 49⅝ x 61¼". Signed lower right. Collection Mr. and Mrs. Paul Scott Rankine, Washington, D. C.

*111 *The Plough and the Song.* 1947. Oil on burlap, 52⅛ x 64¼". Signed and dated lower right. Collection Mr. and Mrs. Milton A. Gordon, New York. (Exhibited in New York only). Ill. p. 47

*112 *The Plough and the Song.* 1947. Oil on canvas, 50¾ x 62¾". Signed and dated lower right. Allen Memorial Art Museum, Oberlin College, Oberlin, Ohio. Ill. p. 46

"PASTORAL" (1946-47)

113 Drawing. 1946. Wax crayon and pencil, 18⅞ x 24⅝". Signed and dated center left. Collection Ethel K. Schwabacher, New York

114 Drawing. 1946. Pencil and wax crayon, 23 x 29". Signed and dated center right. Estate of Arshile Gorky

115 *Terra Cotta.* 1947. Oil on canvas, 44¼ x 56". Signed and dated upper left. Collection Mr. and Mrs. Frederick R. Weisman, Beverly Hills, Calif.

116 *"Pastoral."* 1947. Oil on canvas, 44 x 56¾". Signed and dated center right. Estate of Arshile Gorky

*117 Study for *Soft Night.* 1946. Pencil and wax crayon, 19½ x 24⅝". Signed and dated upper left. Estate of Arshile Gorky. Ill. p. 48

*118 *Soft Night.* 1947. Oil on canvas, 38 x 50". Signed and dated left, below center. Collection Ruth Stephan, Greenwich, Conn. Ill. p. 48

*119 Study for *"Dark Green Painting."* 1946. Pencil and wax crayon, 19 x 24". Signed and dated lower left. Estate of Arshile Gorky. Ill. p. 49

*120 *"Dark Green Painting."* (c. 1948). Oil on canvas, 43⅞ x 55⅞". Signed upper right. Collection Mrs. H. Gates Lloyd, Haverford, Pa. Ill. p. 49

121 *"Last Painting."* (1948). Oil on canvas, 30¾ x 39¾". Estate of Arshile Gorky

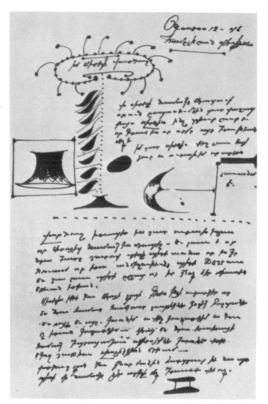

Letter from Gorky to his sister Vartoosh. Hamilton, Virginia, August 12, 1946.

Museum of Modern Art Publications in Reprint

Abstract Painting and Sculpture in America. 1951. Andrew Carnduff Ritchie

African Negro Art. 1935. James Johnson Sweeney

American Art of the 20's and 30's: Paintings by Nineteen Living Americans; Painting and Sculpture by Living Americans; Murals by American Painters and Photographers. 1929. Barr; Kirstein and Levy

American Folk Art: The Art of the Common Man in America, 1750-1900. 1932. Holger Cahill

American Painting and Sculpture: 1862-1932. 1932. Holger Cahill

American Realists and Magic Realists. 1943. Miller and Barr; Kirstein

American Sources of Modern Art. 1933. Holger Cahill

Americans 1942-1963; Six Group Exhibitions. 1942-1963. Dorothy C. Miller

Ancient Art of the Andes. 1954. Bennett and d'Harnoncourt

The Architecture of Bridges. 1949. Elizabeth B. Mock

The Architecture of Japan. 1955. Arthur Drexler

Art in Our Time; 10th Anniversary Exhibition. 1939.

Art Nouveau; Art and Design at the Turn of the Century. 1959. Selz and Constantine

Arts of the South Seas. 1946. Linton, Wingert, and d'Harnoncourt

Bauhaus: 1919-1928. 1938. Bayer, W. Gropius and I. Gropius

Britain at War. 1941. Eliot, Read, Carter and Dyer

Built in U.S.A.: 1932-1944; Post-War Architecture. 1944. Mock; Hitchcock and Drexler

Cézanne, Gauguin, Seurat, Van Gogh: First Loan Exhibition. 1929. Alfred H. Barr, Jr.

Marc Chagall. 1946. James Johnson Sweeney

Giorgio de Chirico. 1955. James Thrall Soby

Contemporary Painters. 1948. James Thrall Soby

Cubism and Abstract Art. 1936. Alfred H. Barr, Jr.

Salvador Dali. 1946. James Thrall Soby

James Ensor. 1951. Libby Tannenbaum

Romantic Painting in America. 1943. Soby and Miller

Medardo Rosso. 1963. Margaret Scolari Barr

Mark Rothko. 1961. Peter Selz

Georges Roualt: Paintings and Prints. 1947. James Thrall Soby

Henri Rousseau. 1946. Daniel Catton Rich

Sculpture of the Twentieth Century. 1952. Andrew Carnduff Ritchie

Soutine. 1950. Monroe Wheeler

Yves Tanguy. 1955. James Thrall Soby

Tchelitchew: Paintings, Drawings. 1942. James Thrall Soby

Textiles and Ornaments of India. 1956. Jayakar and Irwin; Wheeler

**Three American Modernist Painters: Max Weber; Maurice Sterne; Stuart
Davis.** 1930-1945. Barr; Kallen; Sweeney

**Three American Romantic Painters: Charles Burchfield: Early Watercolors;
Florine Stettheimer; Franklin C. Watkins.** 1930-1950. Barr; McBride; Ritchie

**Three Painters of America: Charles Demuth; Charles Sheeler; Edward
Hopper.** 1933-1950. Ritchie; Williams; Barr and Burchfield

Twentieth-Century Italian Art. 1949. Soby and Barr

Twenty Centuries of Mexican Art. 1940

Edouard Vuillard. 1954. Andrew Carnduff Ritchie

The Bulletin of the Museum of Modern Art, 1933-1963. (7 vols.)